NATIVITIES
OF THE WORLD

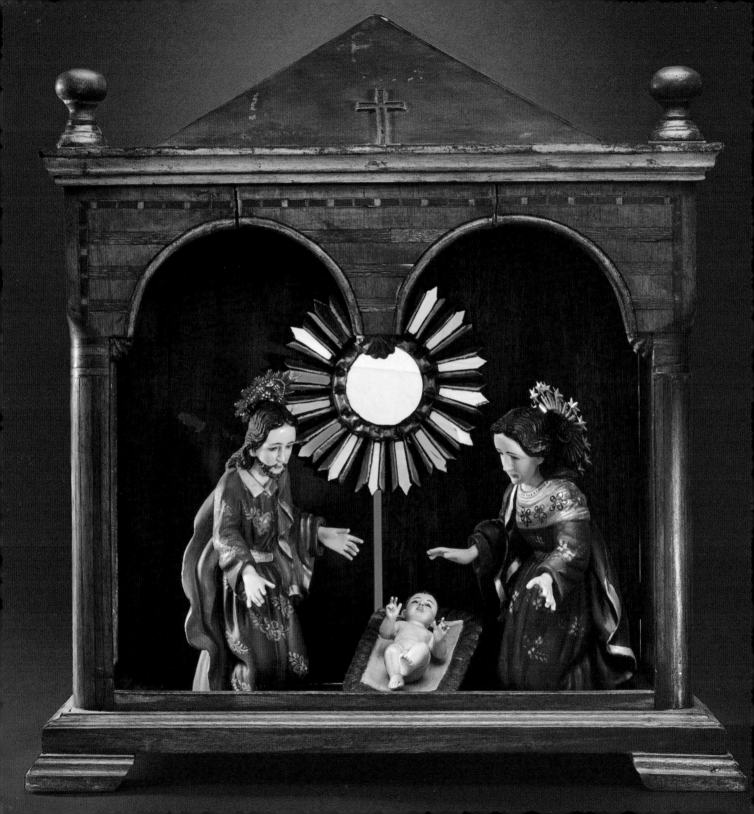

NATIVITIES
OF THE WORLD

SUSAN TOPP WEBER

PHOTOGRAPHS BY BLAIR CLARK AND RANDY MACE

GIBBS SMITH
TO ENRICH AND INSPIRE HUMANKIND

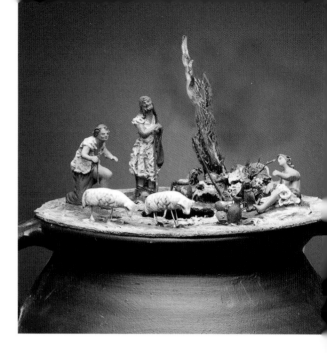

First Edition
17 16 15 14 13 5 4 3 2 1

Published by
Gibbs Smith
P.O. Box 667
Layton, Utah 84041

1.800.835.4993 orders
www.gibbs-smith.com

Designed by Rita Sowins / Sowins Design
Printed and bound in China

Gibbs Smith books are printed on either recycled, 100% post-
consumer waste, FSC-certified papers or on paper produced from
sustainable PEFC-certified forest/controlled wood source.
Learn more at www.pefc.org.

Library of Congress Cataloging-in-Publication Data

Weber, Susan Topp.
 Nativities of the world / Susan Topp Weber ; Photographs by
Blair Clark and Randy Mace. — First Edition.
 pages cm
 ISBN 978-1-4236-3246-7
1. Crèches (Nativity scenes) I. Title.
 N8065.W417 2013
 704.9'4856—dc23
 2012051242

SPANISH NATIVITY SET IN A
MILK CROCK (1975)
PHOTOGRAPH BY BLAIR CLARK (SEE PAGE 18)

This book is dedicated to Ruth Weber, who gave me some of my favorite nativities nearly 50 years ago, and to Judith Davis, who prepared A Guide to Permanent Nativity Displays in the United States and Around the World for Friends of the Creche, of which she is a founding member.

ACKNOWLEDGMENTS

This book would not have been possible without the generous assistance of many people. I would like to thank Max and Joyce Douglas, Judith Davis, Dagmar Kubaštová Vrkljan, Mary Ann Adams, Suzy O'Neill, Jerilyn Christiansen, Jane Braithwaite, Kathy Chilton, Noel Chilton, Lores Klingbeil, Alice Mann, Tom and Ellen Kocialski, Blair Clark, Randy Mace, Ben Allison, Ramón José López and Nancy López, Paul Baumann and Roger Miller of Poco A Poco Imports, Nellie Pace of Peruvian Imports, Michael Peters of Cruz Imports, Patricia La Farge of Que Tenga Buena Mano, Tony Jones of Traveling Trunk, Maribel Siman-Delucca of Arara Imports, Anne Ritchings, Susan Summers, Peggy Ater, Carol Ann Mullaney, Armando Lopez and Scott Markman, Wendy Wiele, Dona and Paul Cook, Melissa Weber, Mike Weber, Frances Mann, Louise Alvarez, Ann Reynolds Smith, John Stafford, and Becky Maidment. I'm grateful to all the interested customers and friends who viewed my huge album of photographs that were considered for the book; and to the wonderful employees at my shop, whose help made it possible for me to write this book: Karen Sears, Susan McArthur, Karen Fuhrhop, Leah Kostoplos, and especially Terre Reed.

CONTENTS

PREFACE

Nativities have long been an important part of my life. I have a prized collection of them myself, which began with a gift in 1965. I have sold nativities at Susan's Christmas Shop since 1978. Membership in Friends of the Creche, a national organization for those interested in nativities, led to my sponsoring their biennial convention in Santa Fe in 2005 and to friendships with other collectors. Many of these collectors have generously allowed their nativities to be photographed for this book. I have had opportunities to see nativities in museums in Europe and the Americas, and have seen thousands of nativities in the process of writing this book. I have chosen ones that pleased me and have not, for the most part, yet appeared in any book. I hope my choices please you as well, and that you will enjoy the book you are holding in your hands.

MOUNTED WISE MEN FROM
PAINTED MEXICAN CLAY
NATIVITY (1990s)
PHOTOGRAPH BY BLAIR CLARK
(SEE PAGE 76)

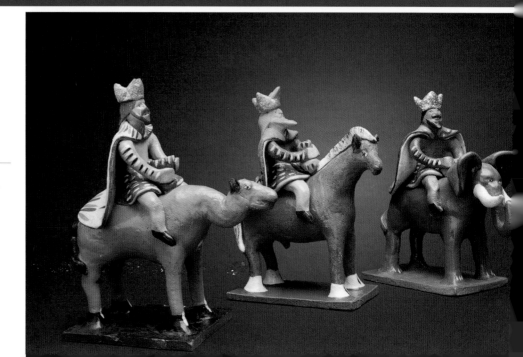

INTRODUCTION

NATIVITIES ARE SIMULTANEOUSLY SIMPLE AND AMAZING. They are simple because they all tell a similar story, the depiction of the birth of Jesus under humble circumstances. They are amazing because they are made in such a tremendous variety of styles and materials and levels of sophistication in a great many countries of the world. Because of this variety they are fascinating to look at, and for some enthusiasts the urge to collect them, or to improve them every year, is almost irresistible.

How did this all begin? It began in Europe as Christianity took root, grew, and flowered. There are said to be a few early drawings suggesting nativity scenes on the walls of Roman catacombs. As the centuries passed, magnificent Romanesque stone churches and cathedrals were built across Europe. The carved stone elements of their facades sometimes depicted nativity themes. Precious medieval books of hours were privately owned by the privileged few for their personal devotions, and these books often contained exquisite hand-painted nativity illustrations. During the Renaissance, painters frequently used religious themes, especially nativities, for their paintings.

Credit for the first three-dimensional nativity is given to Saint Francis of Assisi on Christmas Eve in 1223 in Greccio, a small Italian village. His tableau featured live animals, and had quite a lasting impact. To this day Italians love nativities, and an entire street in Naples, Italy, is devoted to selling them.

Medieval plays were written and performed, depicting various scenes from the nativity story. Medieval Spanish nativity plays were useful for priests in Spain's remote colonies to teach illiterate natives the Spanish hoped to convert to Christianity, as well as illiterate colonists. Since these plays were performed annually, the stories were reinforced and became memorized. Some of these plays are still performed today; in New Mexico they are called Las Posadas, Los Pastores, and Los Tres Reyes Magos.

During the eighteenth century in Naples, nativity sets became quite elaborate. Their figures had limbs with wires at the joints so that they could be posed, and they were often dressed

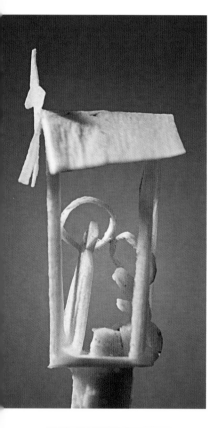

KITCHEN MATCH
NATIVITY FROM
OAXACA, MEXICO
(2003)
PHOTOGRAPH BY BLAIR CLARK
(SEE PAGE 152)

in gorgeous costumes made of rich fabrics. Additional scenes were created depicting many various activities of daily life. These scenes often included fantastic miniature accessories, which created a demand for even more accessories. Neapolitan churches and wealthy families began to compete with each other for the most impressive nativity scenes at Christmas. This fashion spread to Spain. The most magnificent period of nativities in Spain was in the eighteenth century, when Carlos III, after he was made king of the two Sicilies, began the practice of setting up annual nativity displays in his royal palace in Madrid. Soon the wealthy families of Spain adopted the custom of large, elaborate nativity scenes set up for the weeks of the Christmas season.

The areas around Munich, Oberammergau, and Tyrol developed a lovely style of "biblically correct" nativity scenes in the early nineteenth century. They aspired to be historically accurate in the appearance of the various scenes of the nativity story, and the results are delightful to see 200 years later. Currently this style is called "oriental" when it is used in Tyrol, to distinguish it from an alpine style, which is also very popular.

Many of these amazing eighteenth and nineteenth century nativities are now in museums, where they attract and inspire the public. Most American collectors are familiar with the Angel Tree at the Metropolitan Museum of Art in New York City. Other historical nativities are in museums in Europe, such as the Bavarian National Museum in Munich. These historical sets are not the focus of this book, because they are already familiar to many nativity collectors, but they certainly laid the foundation for the nativities that are made and enjoyed today. An appendix to this book lists museums where the major permanent collections of historic nativities may be seen.

In both Italy and Spain today, the urge to enlarge and enhance the family

nativity scene each year continues, and that urge seems to be infinite. Large, artistic background panoramas, architecturally detailed buildings, special materials to use for imitating hills and mountains, elaborate moving figures powered by electricity, fancy lighting, rivers and fountains using real water, and a wide variety of accessories can all be purchased for this purpose. Needless to say, setting up such a scene is quite an undertaking. Competitions are held in Italy for the best displays, and one of the great pleasures of the Christmas season is viewing the many nativity scenes in churches and private homes. And in some of Spain's former colonies, such as Colombia and Mexico, ambitious nativity scenes are also set up.

In the New World, especially in Spain's colonies, indigenous peoples began to interpret the nativity story through their own cultural lenses. These special nativity sets were, and are, attractive to travelers and collectors. Elsewhere in the world, wherever Christian missionaries worked, more nativities came to be made, often looking like the people of that culture. A new style of collecting nativities emerged in the mid-twentieth century, partially inspired by several popular museum shows featuring Alexander Girard's famous collection of international nativities.

The typical collector in the United States now prefers to accumulate as many different nativity sets as possible, rather than to enlarge and enhance one set as is typically done in Europe. Huge private collections have resulted, and many nativities in this book come from these collections. In addition, churches in the United States often sponsor exhibitions of nativities drawn from the collections of their congregations. A national American organization of nativity collectors, Friends of the Creche, was created in 2000. This organization is modeled after similar organizations in Europe. The result is what this book has to offer: a wide selection of handmade nativities from all over the world to delight the eye and inspire the mind. The more familiar styles of nativities will not appear here, in order to provide both experienced collectors with views of unseen material as well as introduce novice collectors to some of the amazing variety of international nativities. The nativities shown in this book, with a few exceptions, have never before appeared in any book.

WESTERN EUROPE

EIGHTEENTH-CENTURY REPRODUCTION NATIVITY FROM NAPLES, ITALY (2006)

31 in. (78 cm.) tall
Collection of Max and Joyce Douglas, Denver, Colorado
PHOTOGRAPH BY RANDY MACE

+++

This is an example of the famous Italian Baroque—style nativity from Naples, Italy. The ruins of Roman civilization are often included in eighteenth-century Italian sets, alluding to the rise of Christianity over pagan Rome. Beneath Mary's feet is a piece of a broken Roman column caught beneath an arch. The fabrics used are fine silks. The hands and heads are terra-cotta. Antique examples that are not already in museums are very costly, so reproductions are now made for those who enjoy this classic eighteenth-century style of nativity. This one is especially large and well made. It was ordered from a shop on the famous nativity street in Naples and shipped to the collector's home in the United States.

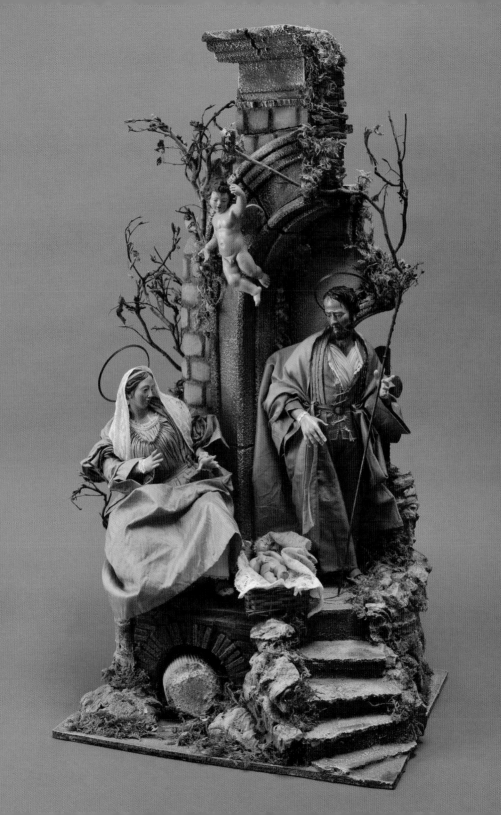

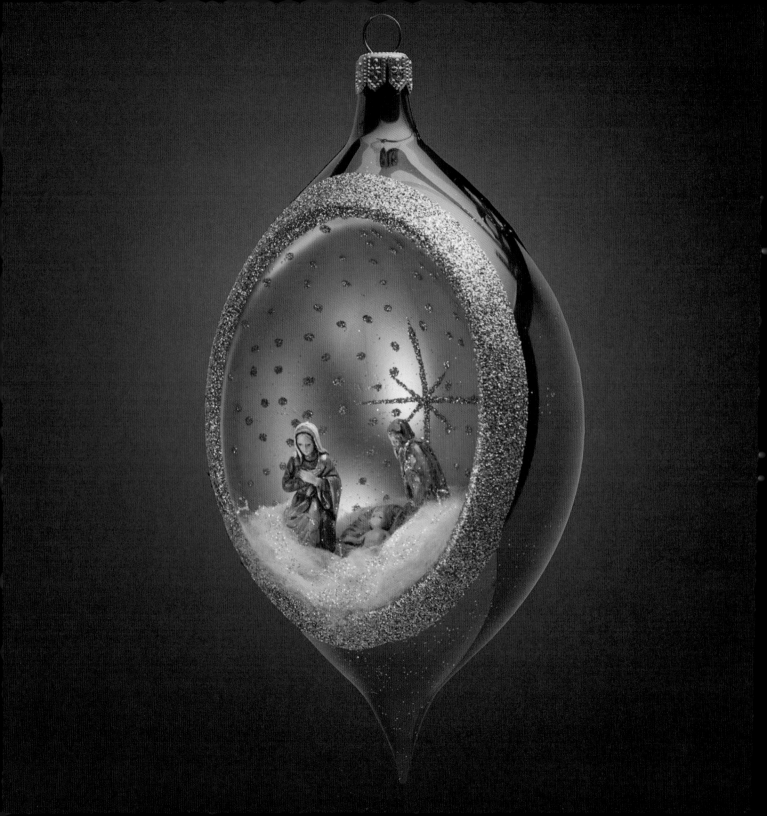

ITALIAN GLASS ORNAMENT WITH NATIVITY (2011)

About 4 in. (10 cm.) tall
Private collection
PHOTOGRAPH BY BLAIR CLARK

++

Italian glass Christmas ornaments are blown by mouth using clear glass tubes heated over a gas flame. They are formed by hand while the glass is molten, rather than by using molds. Next, the interior is coated with a liquid silver solution to make the ornament reflective and shiny. Then the meticulous hand painting begins, followed by the glitter, the angel hair, and the careful gluing in place of the tiny nativity figures. The entire process may take a week. The result is quite lightweight, elegant, and perfect for a Christmas tree.

AUSTRIAN WOODEN NATIVITY (1999)

The tallest figure is 6½ in. (16 cm.)
Collection of Max and Joyce Douglas, Denver, Colorado
PHOTOGRAPH BY RANDY MACE

+++

This nativity is made of meticulously hand-carved wood, which has been
carefully stained and painted. It was made by LEPI, an Italian company, but
the costumes of the figures represent the Tyrol region. The style is more
contemporary, especially the light-hearted, barefooted angel suspended
above the scene. The set is full of delightful details, so look closely.

SPANISH NIÑO (1970s)

14 in. (35 cm.) tall
Author's collection, Santa Fe, New Mexico
PHOTOGRAPH BY BLAIR CLARK

+ +

This *niño,* or baby Jesus, was purchased in Seville, Spain, as a gift to the author from her sister, Astrid. He is wooden, with gesso, paint, glass eyes, and a metal halo. He is used alone, without other figures. The style is typical of Spain, but the size makes him special. This *niño* is laid beneath the author's Christmas tree at Christmastime, where he gazes up at all the beautiful ornaments.

SPANISH NATIVITY SET IN A MILK CROCK (1975)

18 in. (46 cm.) tall

Collection of Mary Ann Adams, Albuquerque, New Mexico

PHOTOGRAPH BY BLAIR CLARK

+++

This large clay milk crock may never have held milk. One side has been cut out to frame a nativity diorama, and the back walls have been painted with a scene of blue sky and palm trees. A delightful small angel is wired inside, high above the scene. The figures are pressed clay, in a style made in Barcelona. On the lid is a shepherds' scene with a campfire and sheep. The scene is inverted to make a lid when the nativity is stored, but the central hole in this scene suggests that the introduction of electric light could bring even more drama to an already dramatic tableau.

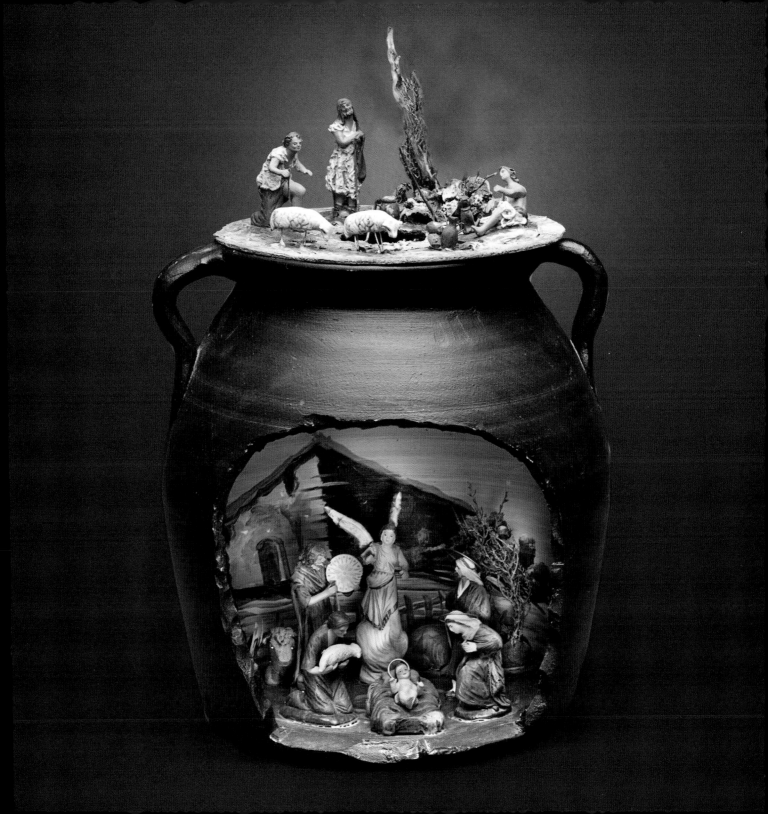

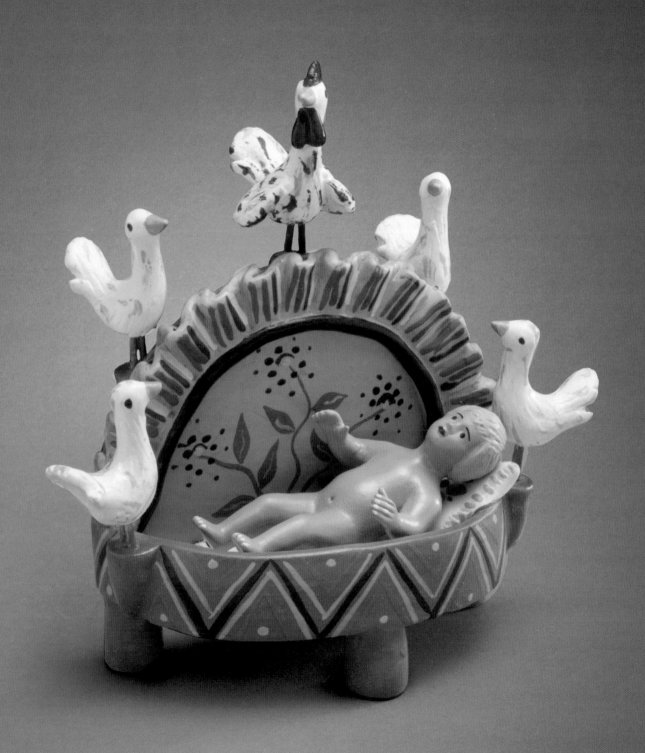

POTTERY BABY JESUS FROM ESTREMOZ, PORTUGAL (1990s)

The baby Jesus is about 3 in. (7 cm.) long
Collection of Suzy O'Neill, Santa Fe, New Mexico
PHOTOGRAPH BY BLAIR CLARK

+++

The small village of Estremoz in Portugal is close to the border between Spain and Portugal. In the eighteenth and nineteenth centuries, handmade clay figures were made there, but the craft eventually died out. In the first half of the twentieth century, a professor persuaded a local Estremoz woman to begin making figures again. They were still being made in the 1980s, when the author was there, and hopefully they are still being made today by a small family business. The baby Jesus, all alone here, is surrounded by flowers and looking up at the birds. The rooster is a popular theme in Portuguese crafts. A complete Estremoz nativity is in the Girard Wing of the Museum of International Folk Art in Santa Fe, New Mexico.

POTTERY NATIVITY BY RITA MÜLLER OF GENEVA, SWITZERLAND (2008)

The tallest figure is about 12 in. (30 cm.)
Collection of Max and Joyce Douglas, Denver, Colorado
PHOTOGRAPH BY BLAIR CLARK

++

The artistic, contemporary style of this nativity is very different from most in this book. It is made of high-fired clay with distinctive touches of green glaze. Baby Jesus sits up in his bed with his arms stretched out on both sides, suggesting a cross. The palm trees here were not made by the artist, but were found elsewhere and added to the set. Palm trees always suggest Bethlehem, and are often used to represent that location in nativity sets.

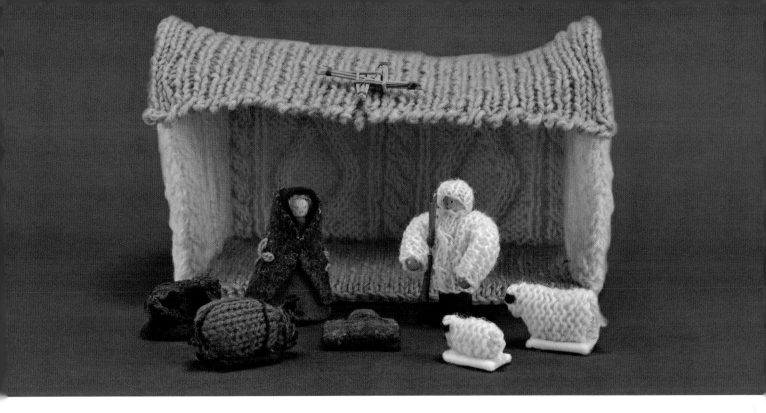

IRISH KNIT NATIVITY BY BRIGID CURRAN (1987)

The stable is about 7 in. (18 cm.) tall and 10 in. (25 cm.) wide
Collection of Max and Joyce Douglas, Denver, Colorado
Photograph by Randy Mace

+ +

Ireland is famous for hand-knit Aran sweaters with their complex stitches. An experienced Irish knitter used her skills to create this nativity scene. The stable is fashioned after the traditional cottages of rural Ireland. The roof holds a Saint Brigid's cross woven of straw. The dark lump on the left is a turf pile. This material is cut from peat bogs and burned as fuel. Mary has a traditional red petticoat and a cape of handwoven Donegal tweed. Joseph's staff is of black thorn, familiar to Irish farmers. The cottage walls and Joseph's sweater are knit with traditional Aran stitches. Two knit Irish sheep complete the scene. Without Irish sheep, there would be no wool, no yarn, and no knitting.

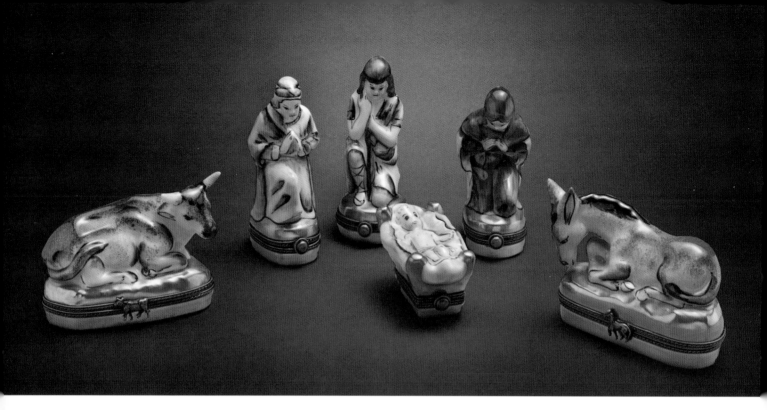

LIMOGES BOXES FROM FRANCE (2006)

The tallest box is about 2 in. (5 cm.)
Collection of Jerilyn Christiansen, Los Alamos, New Mexico
PHOTOGRAPH BY BLAIR CLARK

++

French Limoges boxes are beautiful and collectible, and they are made in many different shapes. This group of boxes makes a nativity, complete with one shepherd. The porcelain boxes are all handmade and hand painted by the same artist. The French shopkeeper where these boxes were purchased refused to sell an angel box to the collector because the angel box was not made by the same artist, and would therefore have spoiled the look of this special group.

FRENCH *SANTON* (1989)

Joseph is 9½ in. (24 cm.) tall
Author's collection, Santa Fe, New Mexico
PHOTOGRAPH BY BLAIR CLARK

+ +

The south of France has a delightful tradition of *santon*. The small, painted, pressed clay *santon* figures are well known to most nativity collectors, so they are not included in this book, but this *santon* set is a larger size, with figures dressed in actual fabric clothes and with clay heads and hands. It was purchased in a picturesque, ancient hill village in the south of France. The baby Jesus can be removed from the manger and placed in Mary's arms.

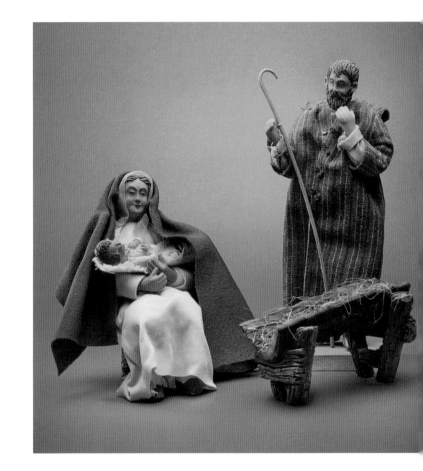

CURLED WOOD NATIVITY ORNAMENT FROM GERMANY (1960s)

3 in. (7 cm.) tall
Private collection
PHOTOGRAPH BY BLAIR CLARK

+++

The special skill of curling wood calls for a very sharp tool, the right kind of wood, and lots of experience. This skill is a specialty of the Erzgebirge, a world-famous mountainous region south of Dresden along the Czech border. To make the ornament, the curls of wood were glued together to make a frame for the tiny nativity figures and a star. This delicate ornament was in the estate of a nativity collector.

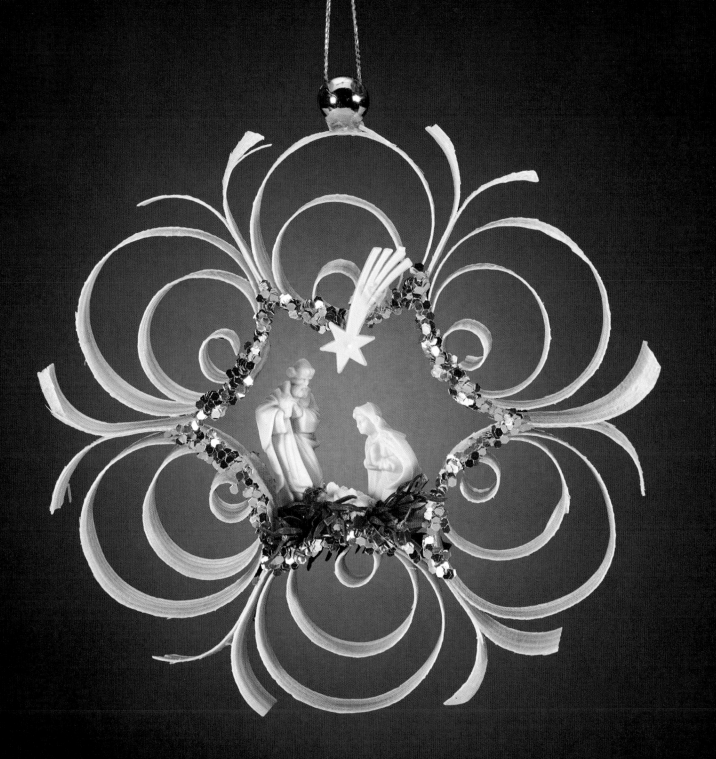

PAINTED PEWTER NATIVITY FROM DIEßEN AM AMMERSEE, GERMANY (2012)

The stable is about 6 in. (15 cm.) tall
Susan's Christmas Shop, Santa Fe, New Mexico
PHOTOGRAPH BY BLAIR CLARK

+++

This two-dimensional painted pewter nativity is based on a three-dimensional eighteenth-century wooden nativity found in the splendid Baroque Marienmünster in Dießen am Ammersee. Dießen is south of Munich on a large lake. The famous antique nativity set in the Marienmünster is called the *Schmädl-Krippe*. Wilhelm Schweizer Pewter of Dießen created the molds for this pewter copy of the *Schmädl-Krippe* in the 1970s, and the molds are still in use today. The Roman column in ruins alludes to the triumph of Christianity over pagan Rome. The star above the stable is unusual because it has a triangle with an eye, a symbol associated with Freemasonry, however it is not unusual in German nativities of this period. This feature is known as "the eye of God."

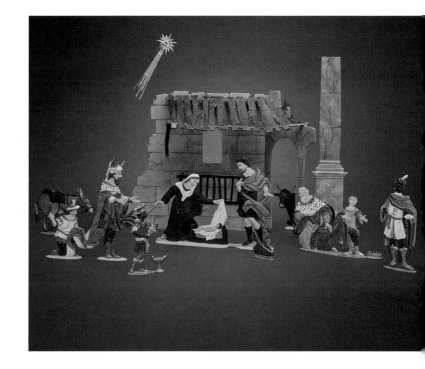

SPANSCHACHTELN KRIPPEN BY DIETER KASTMER OF BAD REICHENHALL, GERMANY (2004)

14½ in. (36 cm.) wide by 6¼ in. (16 cm.) tall
Collection of Max and Joyce Douglas, Denver, Colorado
PHOTOGRAPH BY RANDY MACE

+++

This nativity in a painted wooden box uses antique carved wooden nativity figures set in front of an Alpine chalet, and includes shingles, rocks, vegetation, and craft materials for the mountains. It took over 100 hours of work to make this set. The hand-painted lid of the box depicts the beautiful Saint Bartholomew's Church at one end of the Königssee, a large lake in southern Germany. This nativity was purchased directly from the man who made it.

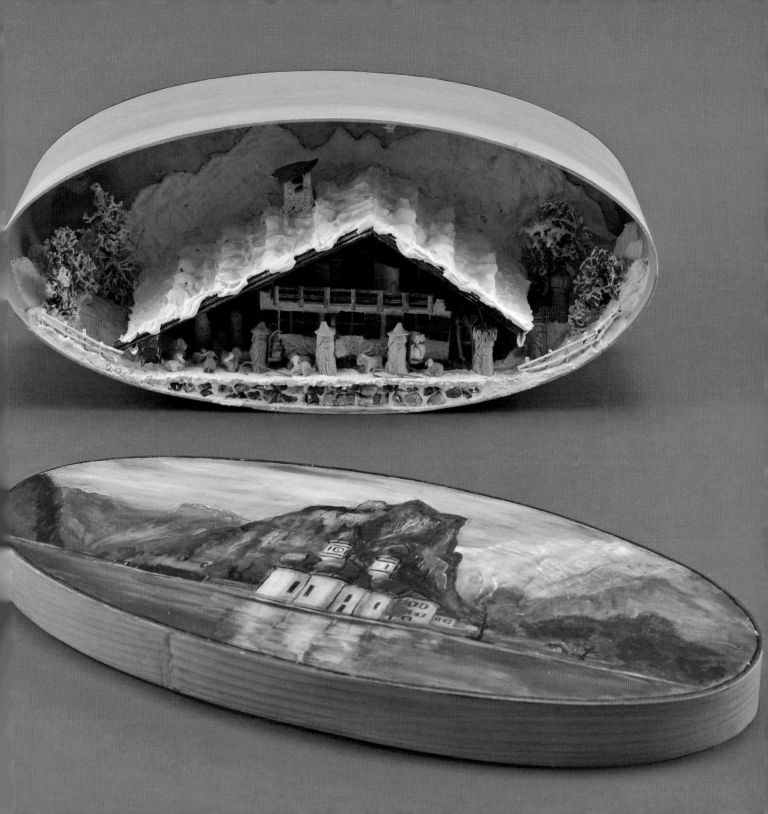

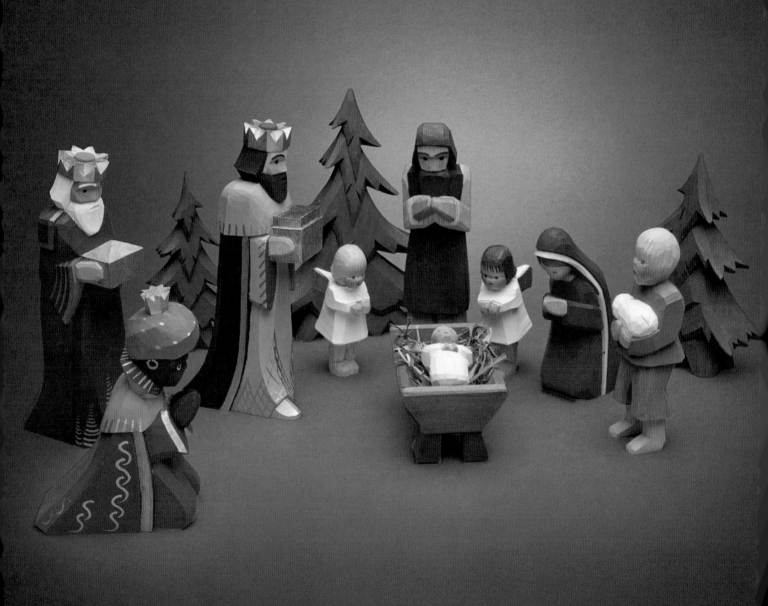

CARVED WOODEN CHILD'S NATIVITY FROM GERMANY (2012)

The tallest king is almost 5 in. (12 cm.)
Susan's Christmas Shop, Santa Fe, New Mexico
PHOTOGRAPH BY BLAIR CLARK

+++

This nativity is completely hand carved and hand painted. The first nativities of this style were made in 1929. The work is still done by the same German family, now the fourth generation. The simply carved shapes are suitable for the hands of young children. The pieces are colorfully painted using oil-based paints, and the style of youthful innocence is very appealing. Joseph wears a carpenter's apron and Mary kneels. It is a favorite nativity of many families, and because it is fairly expensive and sold by the piece, grandmothers often chose to add to the nativity each Christmas. Once their grandchildren grow up and have children of their own, the set is a treasured heirloom from their childhood.

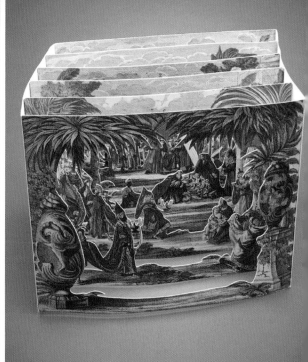

GERMAN EIGHTEENTH-CENTURY CARDBOARD STAGE REPRODUCTION NATIVITY (2008)

4 in. (10 cm.) tall
Collection of the Wiele Family, Albuquerque, New Mexico
PHOTOGRAPH BY BLAIR CLARK

The fashion of Baroque theater architecture was popular in the first half of the eighteenth century. The Engelbrecht brothers of Augsburg made the original of this nativity in the 1720s. The first ones were cut and colored by hand. This unusual reproduction was purchased at the Diocesan Museum in Brixen, Italy. The nativity can be collapsed and laid flat for storage. The six layers of cardboard, each with its own cast of characters, add depth to the scene. The Girard Wing of the Museum of International Folk Art in Santa Fe has many similar theatrical cardboard scenes.

GERMAN OR AUSTRIAN BEESWAX NATIVITY PLAQUE (2003)

8 in. (20 cm.) in diameter
Private collection
PHOTOGRAPH BY BLAIR CLARK

+ +

This fascinating plaque is presumed to be German or Austrian, based on its style, but little is known about the mold used to make it. Smaller German and Austrian wax ornaments made in molds date from the nineteenth century or earlier, and these small ornaments were often painted. This beeswax one is not painted, but the mold used to make it has quite a lot of detail. Its present owner purchased this nativity plaque at one of the biennial conventions of Friends of the Creche, which usually feature a "Manger Mart" where items relating to nativities can be purchased.

EASTERN EUROPE

CZECH POP-UP NATIVITY BY VOJTĚCH KUBAŠTA (1950s)

12 in. (30 cm.) tall
Collection of Dagmar Kubaštová Vrkljan (daughter of the artist), Canada
PHOTOGRAPH BY BLAIR CLARK

+++

Pop-up nativities require creativity, imagination, and the skills of a paper engineer. Vojtěch Kubašta (pronounced *Voy*-tech Ku-*bash*-ta) combined all of these talents to create delightful books and nativities. He was born in Vienna in 1924, but moved to Prague four years later. Prague was his favorite city. Vojtěch had a degree in architecture, but after World War II he worked as a commercial artist. In the 1950s he designed his first pop-up book for children. Since then his books have been published in 22 languages and have sold 35 million copies. His pop-up creations have been featured in museum shows in Europe, and he is considered a master of cardboard and paper pop-ups. This nativity, printed in chromolithography, was his personal favorite because it depicts his beloved Prague.

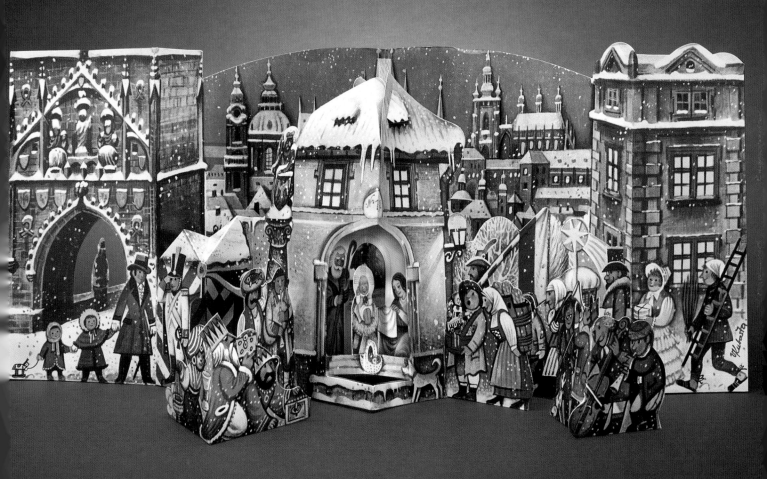

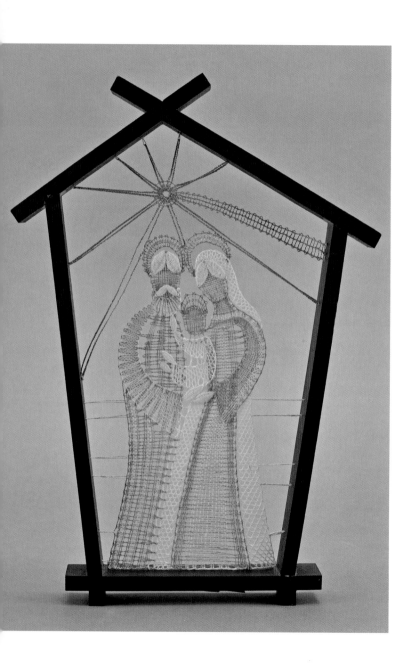

CZECH BOBBIN LACE
NATIVITY (2004)

The wooden frame is 11 in. (28 cm.) tall
Collection of Max and Joyce Douglas,
Denver, Colorado
Photograph by Randy Mace

+ +

Bobbin lace is a labor-intensive technique using a stiff pillow, pins, and wooden bobbins, which are manipulated with great skill. Before machine-made lace killed the market for bobbin lace, there were 30,000 lace makers in the Erzgebirge, a German region bordering the Czech Republic. Grandmothers of today's generation knew how to do it, and they called it *spitzenklöppeln*. Bobbin lace is now done as a hobby. Jana Štefková of Vamberk made this bobbin lace nativity supported by a wooden frame. It was purchased at the 2004 meeting of an international creche congress in Hradec Králové in the Czech Republic.

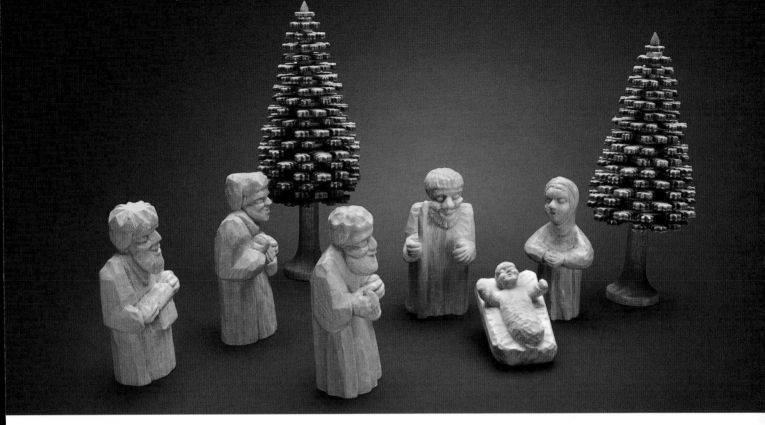

CZECH CARVED NATIVITY (2008)

The nativity figures are 3 in. (7 cm.) tall
Private collection, Canada
PHOTOGRAPH BY BLAIR CLARK

+ +

Dagmar Kubaštová Vrkljan is the daughter of the famous pop-up artist Vojtěch Kubašta. Dagmar moved to Canada long ago, but she still has relatives in the Czech Republic. Her cousin in the Czech Republic carved this simple, small wooden nativity for Dagmar's six-year-old grandson. It was designed for a young child's hands, but it is also a small work of art, which the lucky little boy will own for the rest of his life. The two fascinating wooden trees are not part of the set. They are German and were added to this photograph by the author.

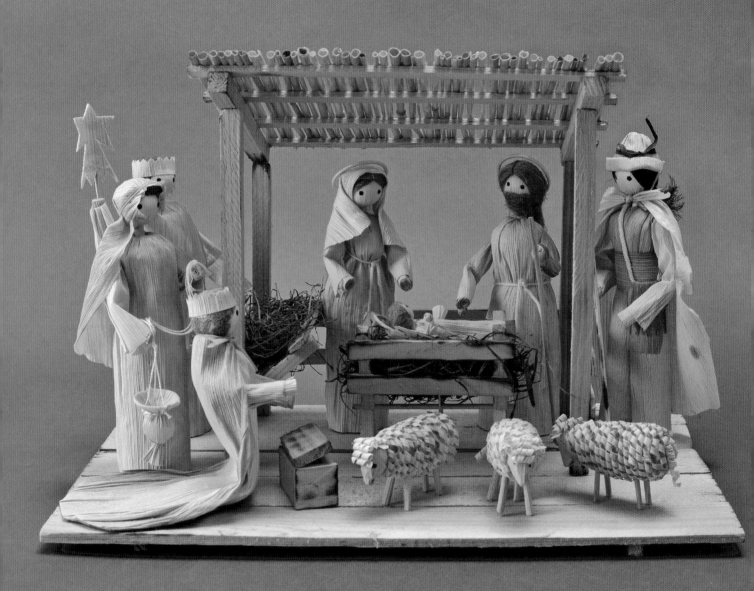

SLOVAKIAN CORNHUSK NATIVITY (2003)

The base is 13 in. (33 cm.) wide

Collection of Max and Joyce Douglas, Denver, Colorado

PHOTOGRAPH BY RANDY MACE

+ +

Slovakia has a tradition of making cornhusk figures depicting scenes of daily life. Here that technique represents a nativity in a simple wooden stable. Quite a bit of detail is created using the simple materials of cornhusk, straw, string, and wood. The sheep are especially appealing with their fleece of curled cornhusk, and the shepherd's jaunty hat, cape, and shoulder bag are nice.

HUNGARIAN POTTERY NATIVITY (2010)

The tallest figure is 5½ in. (14 cm.)
Collection of Carol Ann Mullaney, Santa Fe, New Mexico
PHOTOGRAPH BY BLAIR CLARK

+ +

These pottery nativity figures from Budapest are dressed in traditional Hungarian costumes and baby Jesus is rocked in a cradle of a classic European design. The figures are hand formed and painted with a glossy glaze. The hats and heavy capes suggest cold Hungarian winters. The snowy trees are not of the same provenance as the nativity.

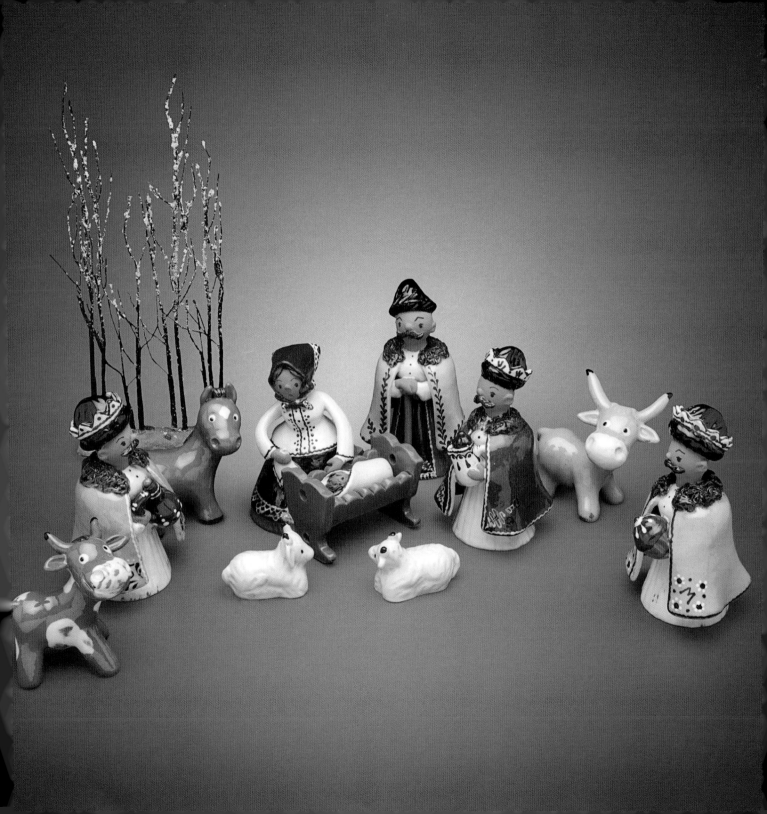

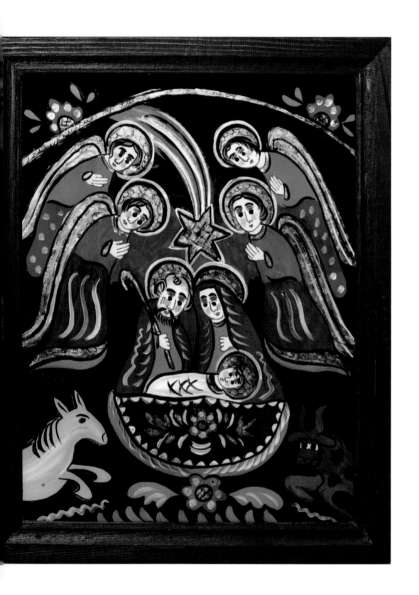

POLISH REVERSE GLASS PAINTING BY EVEDIERA GEKSOVA (1981)

18 in. (46 cm.) tall
Collection of Max and Joyce Douglas, Denver, Colorado
PHOTOGRAPH BY RANDY MACE

++

Reverse glass painting requires the artist to think backward, much as a maker of Ukrainian Easter eggs must do, since the features of the faces are drawn on the glass before the skin color is added. This one has a distinctive Polish folk art style with vivid colors. Reverse glass paintings must be framed in order to protect the paint.

POLISH PAPER CUTOUT NATIVITY BY ELZBIETA KALETA (1991)

22 in. (55 cm.) tall
Author's collection, Santa Fe, New Mexico
PHOTOGRAPH BY BLAIR CLARK

+++

Poland is famous for its paper cutouts, called *wycinanki*. Each color is a separate cut piece of paper. Peasants originally made *wycinanki* using big sheep shears in order to decorate their homes. Elzbieta Kaleta was born in Krakow, but now lives with her husband in Albuquerque, New Mexico, where she designs and creates distinctive paper cutouts and contemporary collages. This *wycinanki* is unusual because of its large size and also for the use of colored foil, which she has tooled from the back before adding it to the composition. The setting is the beloved Wawel Cathedral of Krakow, said to be 1,000 years old, and the source of inspiration for many Polish nativities. When Elzbieta made this masterpiece in 1991, she made only two and kept one for herself. This one is framed and hung in a room with very little light so it will not fade.

CONTEMPORARY-STYLE WOODEN POLISH NATIVITY (1980s)

The tallest tree is 9 in. (23 cm.)

Collection of Jerilyn Christiansen, Los Alamos, New Mexico

PHOTOGRAPH BY BLAIR CLARK

+ +

The trees and figures of this delightful Polish nativity were created with the use of a lathe, a technique also used in the Erzgebirge region of Germany. The turned elements were then cut, stained, assembled, and attached to the wooden base so that nothing moves when this set is lifted. This set's current owner bought the set at the author's Santa Fe shop long ago. Unfortunately, these sets are no longer available.

POLISH CARVED WOODEN NATIVITY WITH PALM TREES (2001)

20 in. (50 cm.) tall
Collection of Mary Ann Adams, Albuquerque, New Mexico
PHOTOGRAPH BY BLAIR CLARK

+ +

This hand-carved wooden set from Poland includes two palm trees, even though they are not found in Poland. Palm trees symbolize the location of Bethlehem, and therefore they are frequently used in nativity scenes. These angels form a heavenly quartet as they play their angelic music for the baby Jesus.

POLISH WOODEN NATIVITY BY HENRYK ABRAMCZYK (1995)

20½ in. (52 cm.) tall
Collection of Max and Joyce Douglas, Denver, Colorado
PHOTOGRAPH BY RANDY MACE

++

The feature that most people notice first is the row of chickens on the rafter above the usual nativity figures. The scene is set in winter, so the pitched roof has painted snow on top, and snow also appears on the two evergreen trees. The artist was a metal worker who began carving actively in his 50s. He has since won many prizes for his work, which is now in museums as well as private collections.

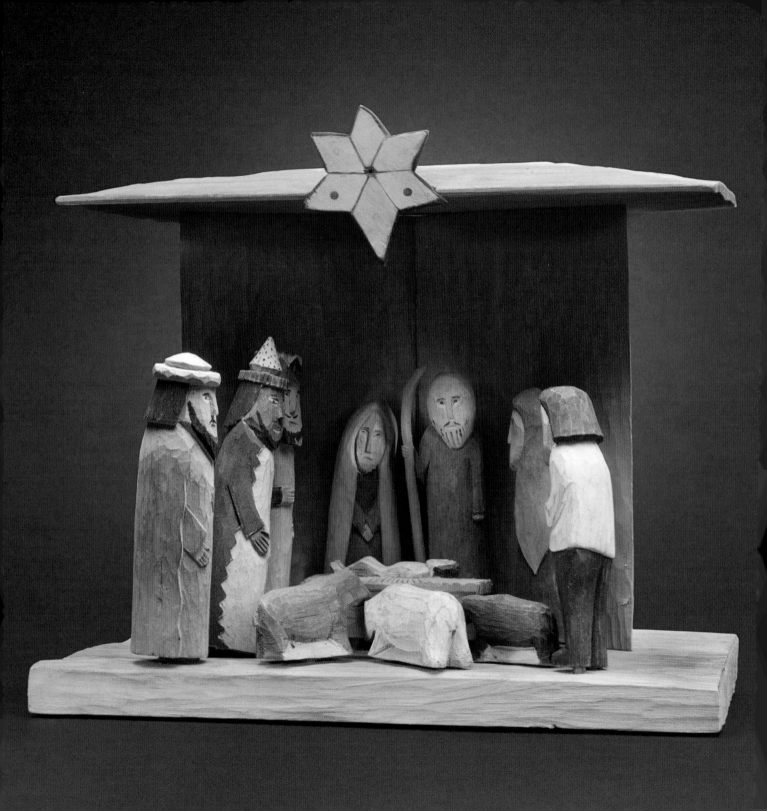

POLISH FOLK ART WOODEN NATIVITY (1985)

9 in. (23 cm.)

Collection of Anne Ritchings, Placitas, New Mexico

PHOTOGRAPH BY BLAIR CLARK

+++

This wooden nativity from Poland has a naïve charm. Simple hand-carved figures of pine were stained and painted, and then pegged into the wooden base. Hand-drawn eyebrows, mustaches, and eyes give life to the figures, especially Mary and Joseph, as well as a self-awareness of the importance of their tableau. The artist seems to be untrained but gifted. This is folk art at its best.

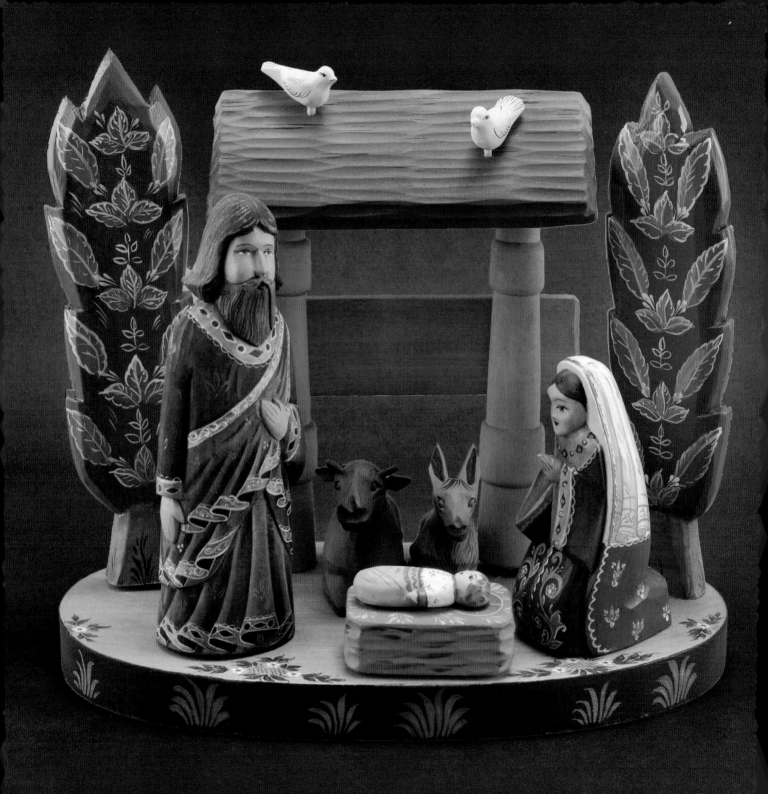

RUSSIAN PAINTED WOODEN NATIVITY (2007)

6 in. (15 cm.) tall

Collection of Max and Joyce Douglas, Denver, Colorado

PHOTOGRAPH BY RANDY MACE

+ +

Carved wooden nativities like this have been made in Russia only since the breakup of the Soviet Union. This example may not be of the highest quality possible, but because it has such a simple, sweet sincerity in the faces, animals, and trees, it was chosen for this book. Most of the best-quality, more sophisticated nativities are exported from Russia for sale abroad, but this one was purchased on a Moscow street, perhaps from its anonymous maker.

AUSTRALIA

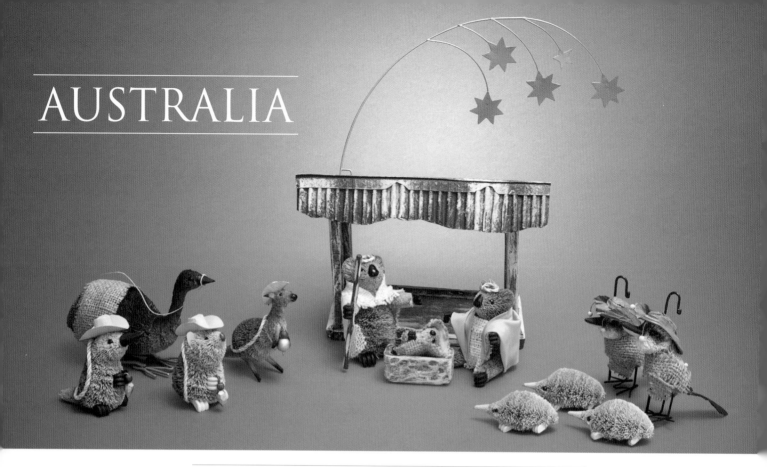

AUSTRALIAN NATIVITY (2010)

The height to the top of the star is 7 in. (18 cm.)
Collection of Becky Maidment, Albuquerque, New Mexico
Photograph by Blair Clark

+ +

This wonderful nativity from Down Under uses natural materials to portray the usual nativity figures as animals found in Australia. Mary, Joseph, and baby Jesus are koala bears. The wise men are a kangaroo, a platypus, and a wombat. The camel is an emu, the shepherds are kookaburras, and the sheep are echidnas. The stable is a tin-roofed structure and the stars overhead represent the Southern Cross. This set always makes people smile.

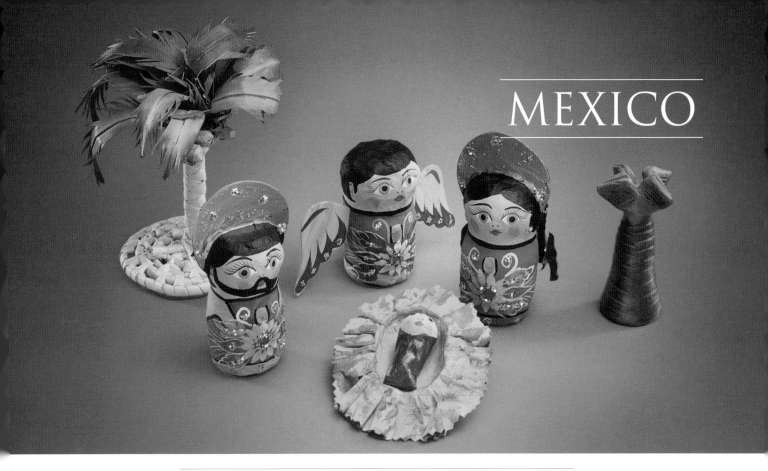

PAPIER-MÂCHÉ NATIVITY BY FRANCISCO CORONELO OF GUANAJUATO, MEXICO (2005)

The tallest figure is 3 in. (8 cm.)
Collection of Suzy O'Neill, Santa Fe, New Mexico
PHOTOGRAPH BY BLAIR CLARK

+ +

Mexico has no competition for the number of styles of nativities made there. This one is from Guanajuato, a state north of Mexico City. The material used to make it is papier-mâché. The little palm tree was added later, as often happens when the owner wants to enhance the scene. The colorful painting, with its detailed faces, exuberant flowers, and touches of glitter, is delightful.

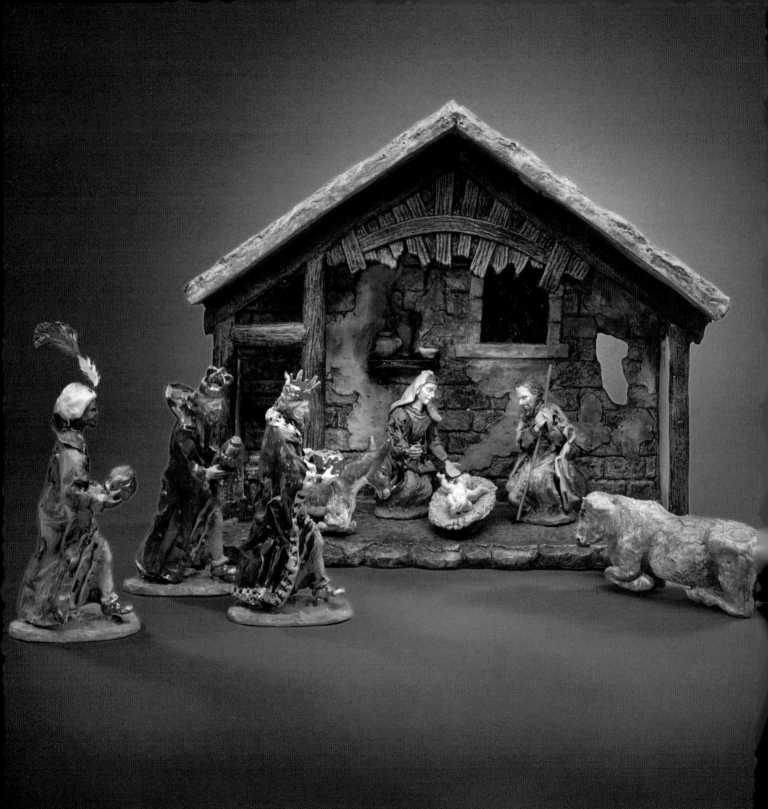

MEXICAN LEAD NATIVITY BY TEODORO TORRES OREA OF MEXICO CITY (1990s)

The tallest figure is 4½ in. (11 cm.)
Private collection
PHOTOGRAPH BY BLAIR CLARK

+++

Teodoro Torres Orea was the only artisan in Mexico who created detailed figures using mariposa metal for his figures and babi metal for soldering them. He also used oil paints and very fine brushes and made many of his own specialized tools. First he created the figures, then clothed them with sheets of lead, as if the lead were actual cloth, and then he added even more details. The figures are very heavy and very special. Teodoro is featured in the 1998 book *Grandes maestros del arte popular Mexicano*, which features the work of many of Mexico's master artists and artisans.

CARVED WOODEN NATIVITY
FROM LA UNION, NEAR TEJALAPAM,
OAXACA, MEXICO (1980s)

The tallest figure is 8½ in. (21 cm.)
Author's collection, Santa Fe, New Mexico
PHOTOGRAPH BY BLAIR CLARK

+ +

La Union is a village 25 kilometers from the city of Oaxaca, a village known for its colorful carved wooden figures. The arms of the figures are made of separate pieces of wood and some arms can be moved. The wise men's arms are holding their gifts and cannot move. A couple of the peasants have burdens slung over their shoulders. The colors are painted with a distinctive stain no longer used today, and the facial features and sandals are drawn by hand. The result is a nativity with rustic, naïve charm that only grows as the years pass.

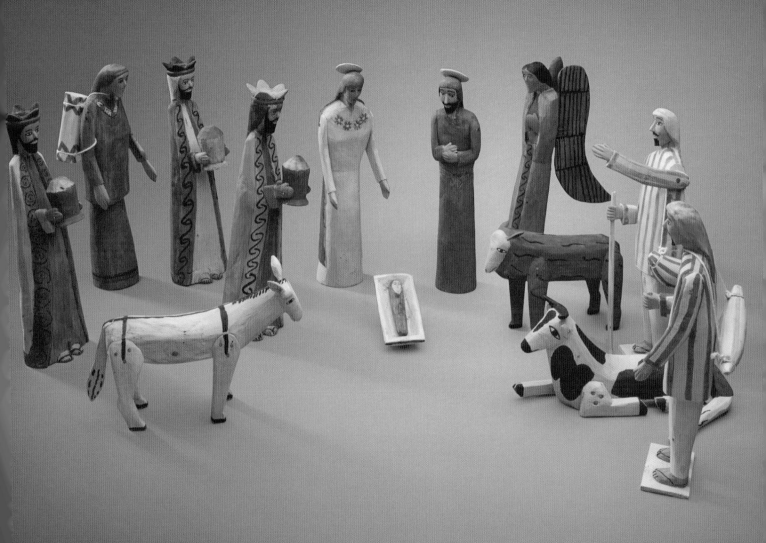

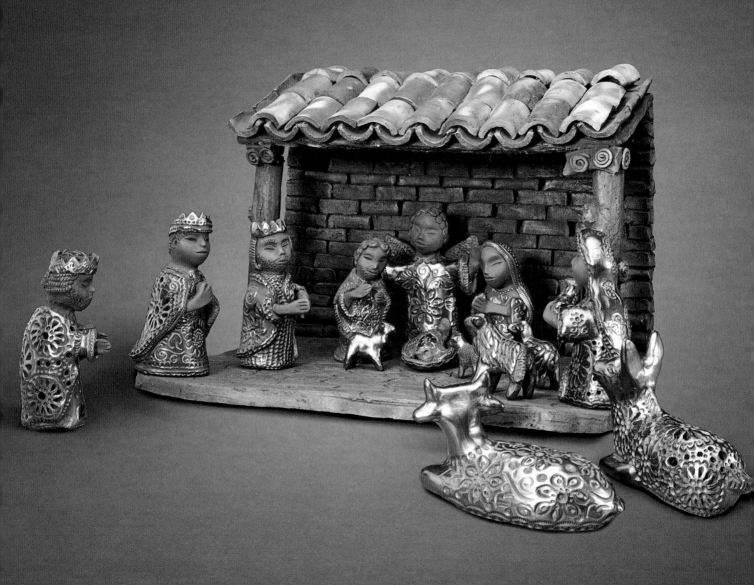

CLAY NATIVITY BY THE DE NIETO CASTILLO FAMILY OF SAN BARTOLO COYOTEPEC, OAXACA, MEXICO (1970s)

The stable is 8 in. (20 cm.) tall
Susan's Christmas Shop, Santa Fe, New Mexico
(from the estate of a collector)
PHOTOGRAPH BY BLAIR CLARK

+++

The famous matriarch of the family who made this nativity was Doña Rosa, who died in 1980. She was a major figure in Oaxacan pottery. She won fame for her ability to achieve a shine by adding quartz to the clay slip, painted on before firing, but only where a shine was desired. Her family still uses her innovative techniques, and the results can be seen here. The heavy clay stable has no shine at all, but it resembles the construction of structures in Oaxaca with its traditional roof of curved clay tiles. The figures are all formed by hand. This set is in the estate of a world traveler.

WOODEN *RETABLO* BY DAVID VILLAFAÑE OF OAXACA CITY (1960s)

36½ in. (93 cm.) tall
Susan's Christmas Shop, Santa Fe, New Mexico
PHOTOGRAPH BY BLAIR CLARK

+++

David Villafañe (1928–1970) is famous for his original large *retablos* with doors that open. The doors contain parts of the nativity scene. The little triangles of wood add a special ornamental element to the frame, and the little sheep suspended in air with wires are a special creative touch by this great master of Mexican folk art. His family continues to make wooden objects, but David's work is still the best, and it brings top dollar when it is sold.

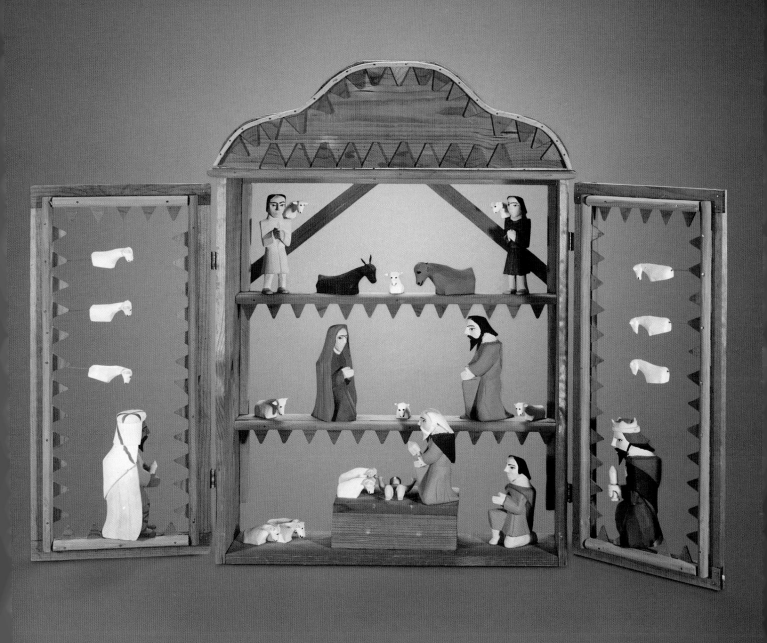

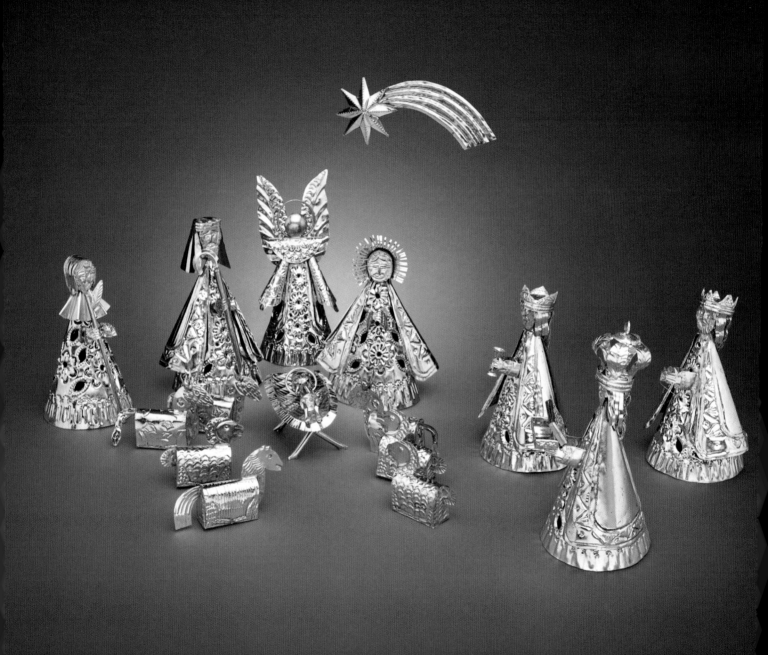

UNPAINTED TIN NATIVITY FROM
OAXACA, MEXICO (1970s)

The tallest figure is 5 in. (13 cm.)
Collection of Dona and Paul Cook, Santa Fe, New Mexico
PHOTOGRAPH BY BLAIR CLARK

+++

This unpainted tin nativity is much more detailed than most. The kings
have separate tin crowns and gifts. Joseph and the shepherd have sepa-
rate tin staffs. Mary is modeled after the Madonna in the Soledad Church
in Oaxaca, close to where this set was made. There is a lot of punched
tinwork on the costumes, and several almond-shaped holes have been cut
in the tin as well.

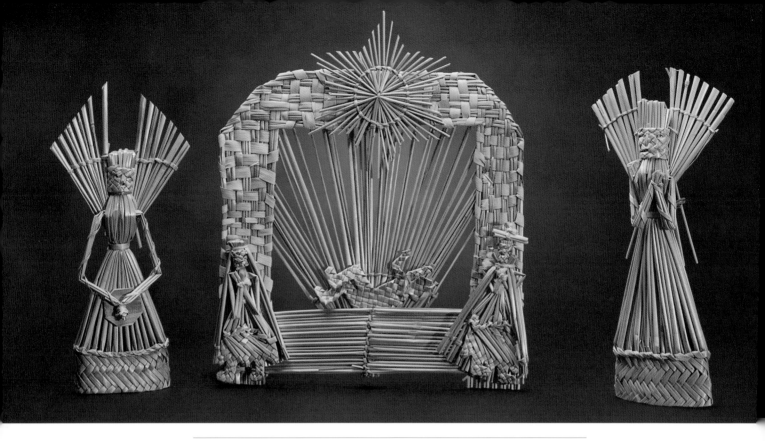

NATURAL WHEAT STRAW NATIVITY FROM TZINTZUNTZAN, MICHOACÁN, MEXICO (1980s)

The nativity is 7 in. (18 cm.) tall; the angels are 6 in. (15 cm.) tall
Private collection, Albuquerque, New Mexico
PHOTOGRAPH BY BLAIR CLARK

+ +

It takes a creative vision to make a nativity out of such simple material as woven wheat straw. Tzintzuntzan in the state of Michoacán is known for woven straw. Mary and Joseph are at either side of the rather large baby Jesus beneath the star. The angel chorus plays various musical instruments to celebrate the joyous occasion.

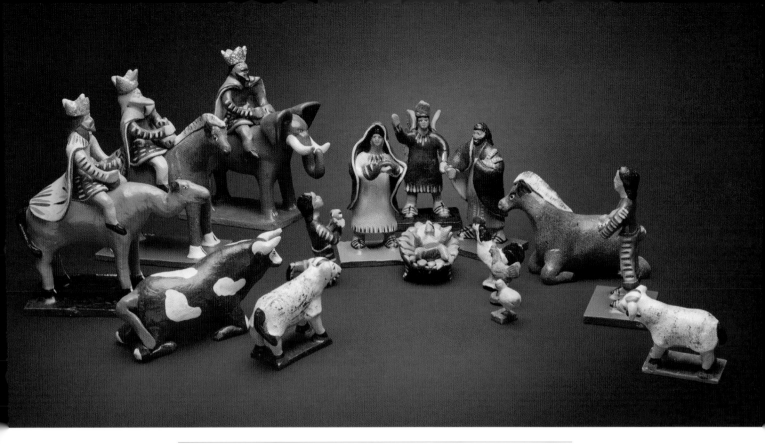

PAINTED MEXICAN CLAY NATIVITY WITH MOUNTED WISE MEN (1990s)

The height of the wise men is 5 in. (13 cm.)
Collection of Carol Ann Mullaney, Santa Fe, New Mexico
PHOTOGRAPH BY BLAIR CLARK

+ +

This colorful hand-formed nativity also presents the wise men sitting on an elephant, a horse, and a camel. This is always an achievement when clay is the medium. The carefully painted eyes of these animals give them a special awareness. Baby Jesus lies on a bed of large green leaves. Mary, Joseph, the angel, and the peasants all wear fancy sandals painted onto their feet. The specific region of Mexico where this was made is unknown, but it is very special.

PAINTED CLAY NATIVITY BY TOMÁS OF IZÚCAR DE MATAMOROS, MEXICO (1970s)

5 in. (13 cm.) tall
Private collection
PHOTOGRAPH BY BLAIR CLARK

+++

This hand-formed, hand-painted clay nativity is in the distinctive style of Izúcar de Matamoros. It is signed "Tomás." Tomás is no longer alive, but family members currently make nearly identical copies of this traditional design and sign them with their names. There is an exuberant love of color and detail here, and the many little birds are delightful.

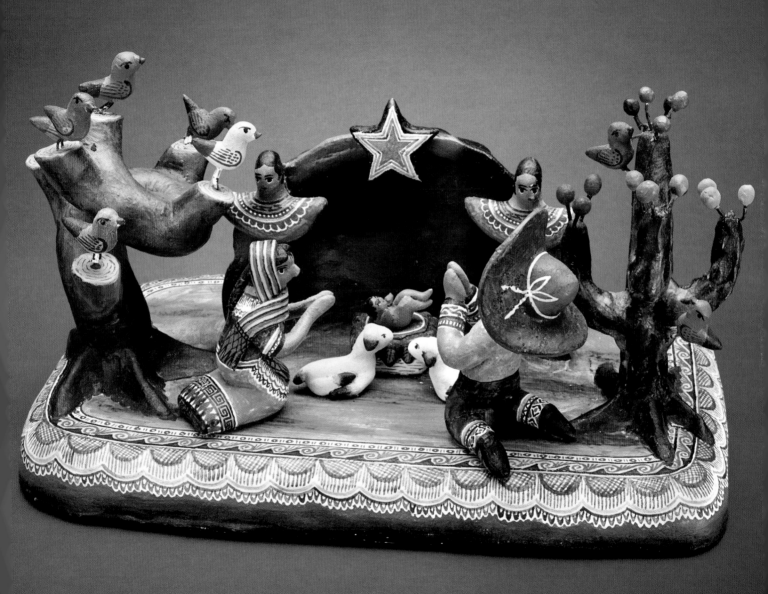

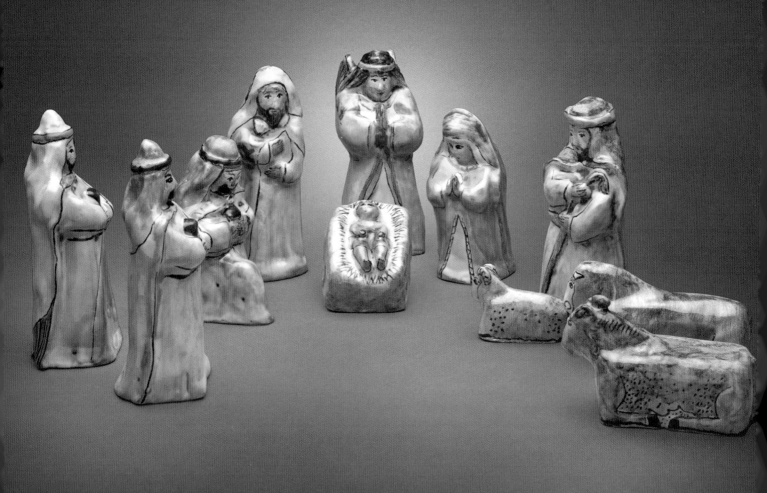

CONTEMPORARY MAJOLICA NATIVITY BY CÉSAR TORRES RAMÍREZ OF PUEBLA, MEXICO (2000)

The angel is 6½ in. (16 cm.) tall
Susan's Christmas Shop, Santa Fe, New Mexico
PHOTOGRAPH BY BLAIR CLARK

+ +

Majolica refers to a distinctive tin oxide glaze, recognized and loved by many. This glaze first came to Spain with the Moors many centuries ago, and the Spanish colonists eventually introduced it to Mexican artisans. Majolica pottery is also found in many other countries, such as Peru, Ecuador, Italy, Holland, England, Hungary, Poland, Bulgaria, Russia, and of course Spain. Puebla, Mexico, is an important center of majolica in Mexico. This nativity is more contemporary and less ethnic in style, with a gentle feeling in its hand painting. The artist is featured in *Grandes maestros del arte popular Mexicano,* the huge 1998 book about masters of Mexican crafts.

CARVED STICK NATIVITY BY HIPÓLITO VÁSQUEZ SÁNCHEZ OF TLAXCALA, MEXICO (1990s)

14 in. (36 cm.)
Private collection
PHOTOGRAPH BY BLAIR CLARK

+ +

This nativity is carved out of one single piece of wood. The artist used the length of the stick to include the elephant, the horse, and the camel as the steeds of the wise men. These are said to represent the different parts of the ancient world from which the wise men traveled to arrive at Bethlehem. This iconography is frequently seen in nativities from Latin American countries. The artist is featured in the 1998 book *Grandes maestros del arte popular Mexicano*.

TARAHUMARA NATIVITY IN A GOURD, MEXICO (2004)

5 in. (13 cm.)
Collection of Mary Ann Adams, Albuquerque,
New Mexico
PHOTOGRAPH BY BLAIR CLARK

+ +

The Tarahumara Indians live in caves in the area
of northern Mexico called Copper Canyon.
Copper Canyon is Mexico's equivalent to the
Grand Canyon of Arizona. The Tarahumara are
famous for their ability to run long distances.
This nativity, set inside a gourd, mimics their cave
homes. The figures are dressed in Tarahumara-
style clothing, and some hold traditional drums.
The little donkey is tied up so he doesn't wan-
der off. Finding a lost donkey in Copper Canyon
would be challenging.

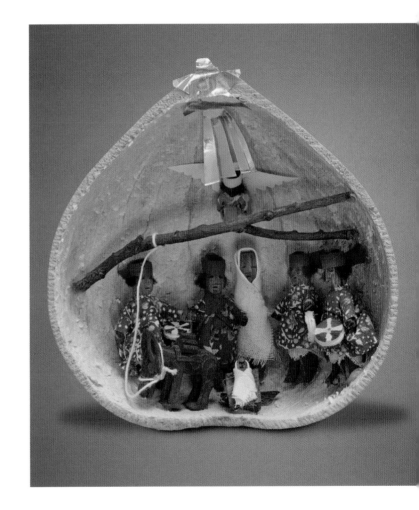

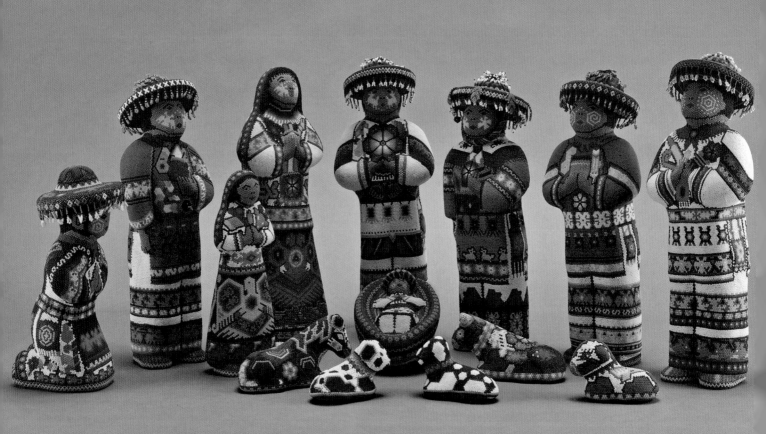

BEADED HUICHOL NATIVITY BY FRANCISCO BAUTISTA OF CALVILLO, MEXICO (2002)

The tallest figure is 11 in. (28 cm.)
Collection of Max and Joyce Douglas,
Denver, Colorado
PHOTOGRAPHS BY RANDY MACE

++

The Huichol Indians of the Sierra Madre of central western Mexico are famous for their yarn paintings and beaded art. Shamans are very important to this deeply religious culture, and most of the figures in this extraordinary nativity wear the shaman's hat with its distinctive beaded fringe around the brim. From the hats down to the toes, all the costuming is ethnically authentic. The elaborate work is created by pressing tiny beads, one at a time, into figures of wood or clay that have been covered with beeswax. A needle helps guide the placement of the bead, so that the hole of each bead is showing. The work is laborious, and the smaller the beads, the longer the time needed to finish. This nativity is as fine an example of Huichol art as one can imagine.

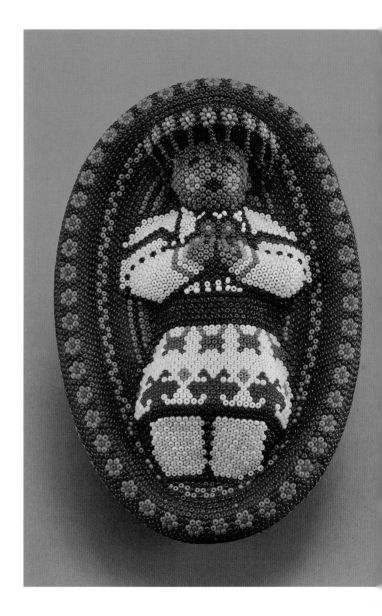

CENTRAL AMERICA

THREE KINGS *SORPRESAS* NATIVITY FROM ILOBASCO, EL SALVADOR (1988)

The height of each king is about 2 in. (5 cm.)
Collection of Max and Joyce Douglas, Denver, Colorado
PHOTOGRAPH BY RANDY MACE

++

The word *sorpresa* means surprise, and in El Salvador it also refers to a pottery scene hidden beneath a lid. When the lid is lifted, one sees the surprise. Nativity *sorpresas* have been made in Ilobasco for many years. Maribel Siman-Delucca designed this unusual variation in the late 1980s. The hidden scenes under the busts of the three kings are the nativity, the shepherds, and the wise men. Maribel was born in El Salvador but now lives in the United States and imports *sorpresas* with her husband. Her father's family made carved shell nativities in Bethlehem before the family immigrated to El Salvador in the early twentieth century. Sadly, the three kings *sorpresas* nativity is no longer available today. Those who own them should feel fortunate.

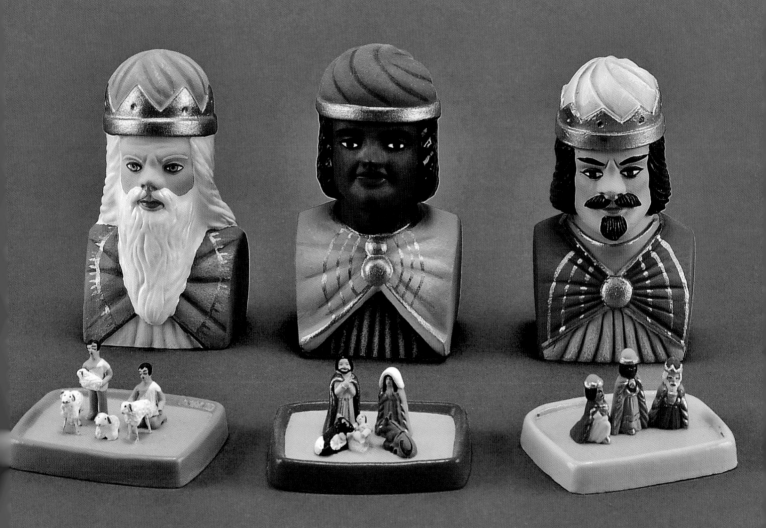

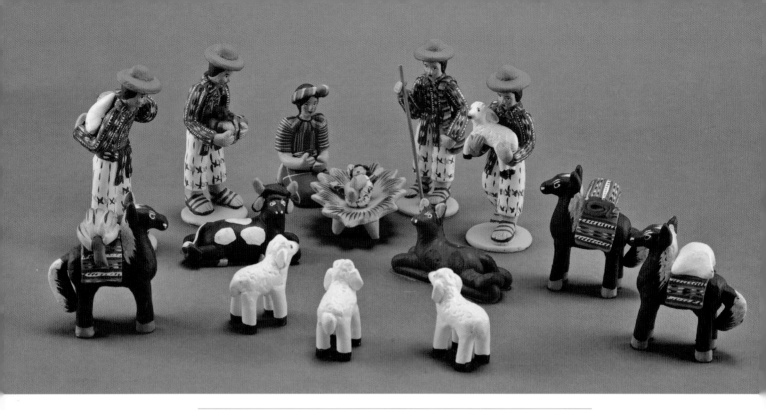

CLAY NATIVITY WITH ETHNIC COSTUMES FROM THE VILLAGE OF SAN ANTONIO PALOPÓ ON LAKE ATITLÁN, GUATEMALA (2011)

The tallest figure is 4½ in. (11 cm.)
Collection of Max and Joyce Douglas, Denver, Colorado
PHOTOGRAPH BY RANDY MACE

+++

Maya women are famous weavers, and the figures of this clay nativity show in great detail the traditional hand-woven clothing of their village on Lake Atitlán. The shirts, the belts, and the pants of the men all show the way men dress so specifically that an anthropologist would know immediately which village produced this nativity. Weaving also seems to be one of the gifts on one of the burros. Other gifts are squash and bananas, but the contents of the white sack is a mystery.

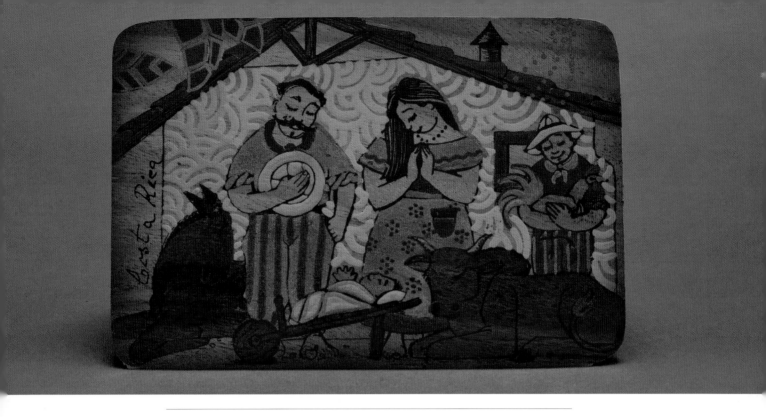

WOODEN POSTCARD FROM COSTA RICA (1989)

6 in. (16 cm.) long
Collection of Max and Joyce Douglas, Denver, Colorado
PHOTOGRAPH BY RANDY MACE

+ +

It's all here on a wooden postcard: the humble stable, the barefooted Mary and Joseph reverently looking at the baby Jesus, the star in the sky, the ox and the ass, and a visitor holding a gift of a rooster. Joseph holds his hat. Mary holds her hands together. The details of their peasant dress are charming. Baby Jesus is laid in a wheelbarrow. He looks happy and his hands are raised. The wood is carefully stained. The talented artist who originally drew this lovely scene remains anonymous. This basic composition has since been borrowed for use on brightly painted, flat, thick, wooden nativity scenes made in El Salvador, but these have none of the charm of this thin wooden postcard.

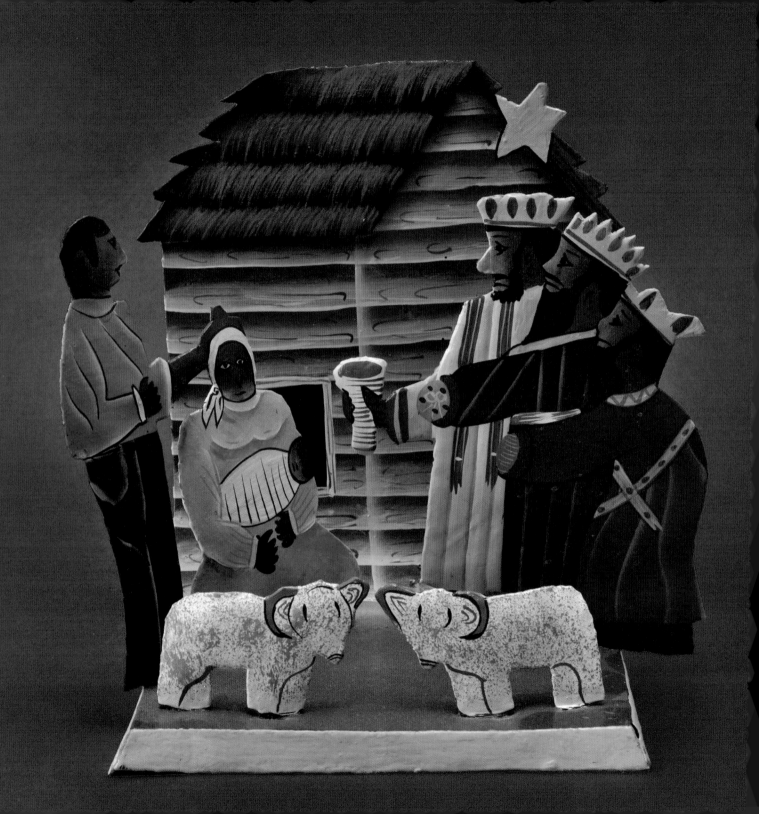

PAINTED TIN NATIVITY FROM HAITI (2006)

7 in. (18 cm.) tall

Collection of Max and Joyce Douglas, Denver, Colorado

PHOTOGRAPH BY RANDY MACE

+ +

Mary and Joseph are in Haitian dress in this brightly painted tin nativity. It ended up in a Ten Thousand Villages shop in Denver, either discovered in Haiti by the retailer, which is a source for international nativities, or made by Haitians specifically at the retailer's request. It successfully depicts the nativity scene in Haitian style, making it appealing to collectors seeking diversity in their collections.

SOUTH AMERICA

RED JEEP NATIVITY FROM COLOMBIA (2005)

The truck is 6 in. (16 cm.) long
Collection of Max and Joyce Douglas, Denver, Colorado
PHOTOGRAPH BY RANDY MACE

++

Pickup trucks and jeeps are useful for carrying passengers and cargo, and this one is being used to carry a nativity. The three wise men approach on foot from the rear. Other cargo is loaded on top of the roof in the classic style of Latin America. The material is clay and the jeep is painted a bright red. This was purchased at the gift shop of the Museum of International Folk Art in Santa Fe, a reliable source for ethnic nativities.

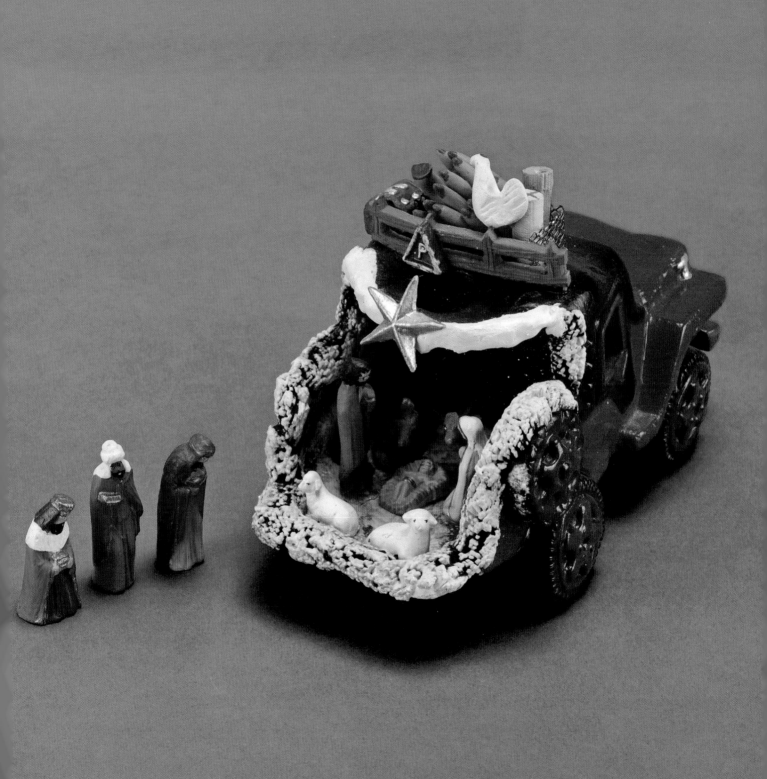

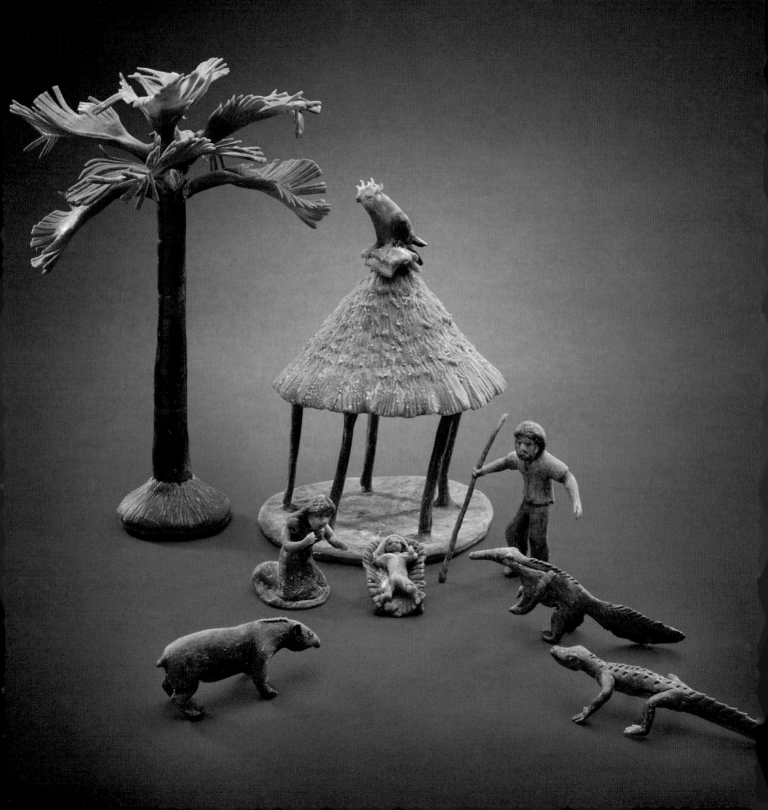

BALATA LATEX NATIVITY FROM GUYANA (1980s)

The palm tree is 7 in. (18 cm.) tall

Collection of Melissa Weber, Tucson, Arizona

PHOTOGRAPH BY BLAIR CLARK

+ +

The rain forests of Guyana include a tree called a bullet tree from which a material called balata is harvested. Balata was first harvested commercially in 1863 and is used in making boots, cable insulation, golf balls, and other items. The local Macushi Indians have used the material to form small figures on a noncommercial basis. This nativity is made of balata, and shows a rain forest hut with a hoatzin, the national bird of Guyana, on the top, a palm tree, and the rain forest animals familiar to the Macushi: the cayman, the anteater, and the sloth. These fascinating nativities are no longer made today.

CLAY SAUCER NATIVITY FROM VENEZUELA (1980s)

The diameter of the saucer is 6 in. (15 cm.)
Susan's Christmas Shop, Santa Fe, New Mexico
(from the estate of a collector)
PHOTOGRAPH BY BLAIR CLARK

+ +

Baby Jesus is literally the center of attention here, and the other figures stand on the rim of the saucer. Each figure is formed by hand and carefully painted. The wise men hold their gifts, and Joseph holds a metal staff. This is in the estate of a world traveler.

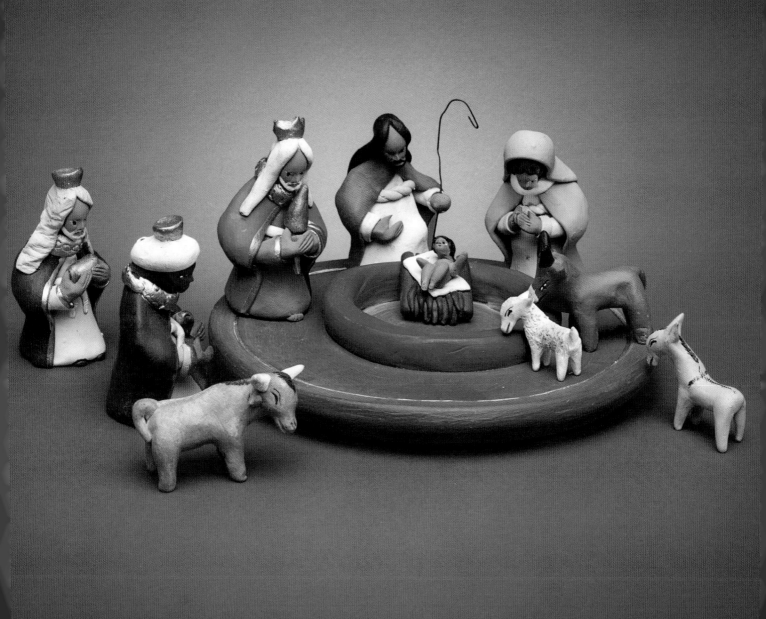

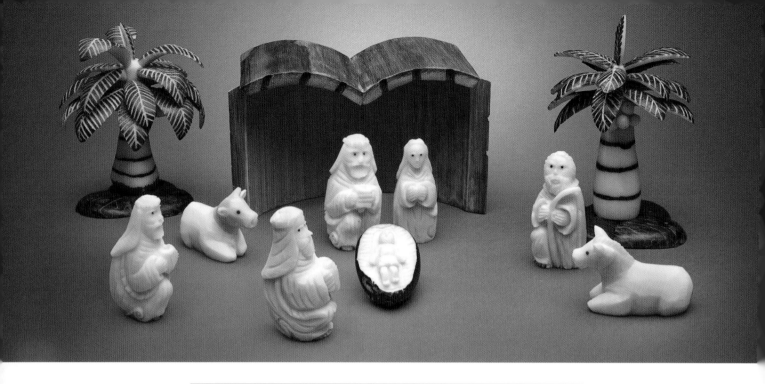

TAGUA NUT NATIVITY FROM ECUADOR (2011)

The palm trees are 5 in. (13 cm.) tall
Susan's Christmas Shop, Santa Fe, New Mexico
PHOTOGRAPH BY BLAIR CLARK

+ +

This nativity was carved out of fresh tagua nuts, which are the product of the elephant palm trees of tropical Ecuador. There are many tagua nuts inside each large shell of the palm tree. The nuts are the size and shape of large Brazil nuts and have a dark skin. Beneath the dark skin is an ivory-colored meat. When they are freshly exposed to air, they are soft enough to carve. Then they become hard, which has earned them the name "vegetable ivory." The baby Jesus in his bed retains the dark outer skin of the tagua nut. The figures of the ox and the ass are both carved from two different nuts for the head and the body of the animals. The palm trees in this nativity are made of many tagua nuts. The rest of the figures are made from single tagua nuts. The stable is made of bamboo.

BASKET NATIVITY WITH DOUGH FIGURES FROM ECUADOR (2011)

The diameter of the basket is 2¼ in. (6 cm.)
Susan's Christmas Shop, Santa Fe, New Mexico
PHOTOGRAPH BY BLAIR CLARK

+ +

Calderón, a town near Quito, Ecuador, is known for its bread dough figures. The dough is made in different colors and each part of the figure is made using dough of the desired color. Often these figures represent a nativity. In this case, miniature nativity figures are fitted into a small handwoven basket that can either sit on a flat surface or hang as a Christmas ornament. Baby Jesus is the center of attention, and the star fits nicely on the handle of the basket.

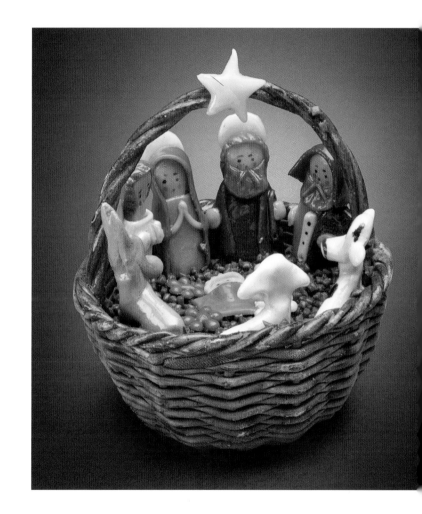

AFRO-PACIFICA NATIVITY FROM ECUADOR (2012)

Joseph is 4½ in. (12 cm.) tall
Private collection
PHOTOGRAPH BY BLAIR CLARK

+ +

This nativity is made of press-molded clay, which is brightly painted after firing. It represents a culture found on the Pacific coast of Ecuador, where former African slaves settled after they achieved their freedom. The figures hold some of the wonderful products of Ecuador. These include bananas, pineapples, other fruits, fish, flowers, and Panama hats. These hats, which have always been woven by hand in Ecuador—not Panama— for the pleasure of connoisseurs around the world, were an important element of both comfort and style in this tropical location.

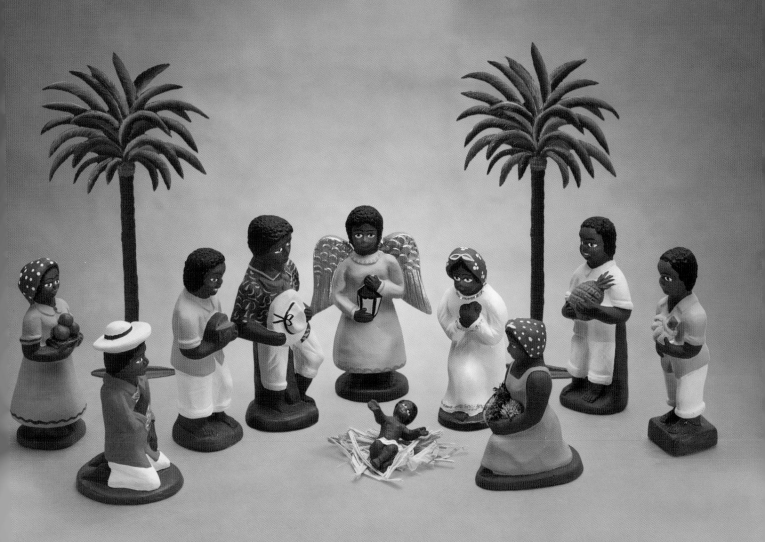

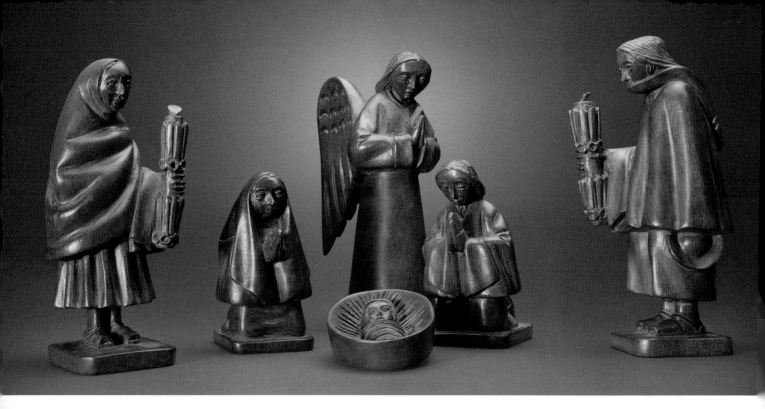

CARVED WOODEN NATIVITY WITH SHAMAN FROM ECUADOR (2011)

The tallest figure is 7 in. (18 cm.)
Private collection

+++

Ecuador has a tradition of woodcarving. This carved wooden nativity is quite unusual because its faces have Indian features. It includes two peasants, one male and one female. Each peasant holds a shamanic bundle intended to protect the baby Jesus. The dark wood is *nogal* (walnut). It was made close to Otavalo, the site of a major market in Ecuador.

WROUGHT IRON HOUSE BLESSING FROM ECUADOR (2011)

18 in. (46 cm.) tall
Private collection
PHOTOGRAPH BY BLAIR CLARK

+ +

The house blessings are hammered into the roofs of new houses in rural Ecuador to provide protection from natural hazards like lightning and floods. This distinctive one uses the image of the Flight into Egypt, a well-known part of the story of the nativity. It is made of hand-forged iron pieces assembled to create an attractive silhouette. Not only is this cheap insurance, it makes one's house easy to find.

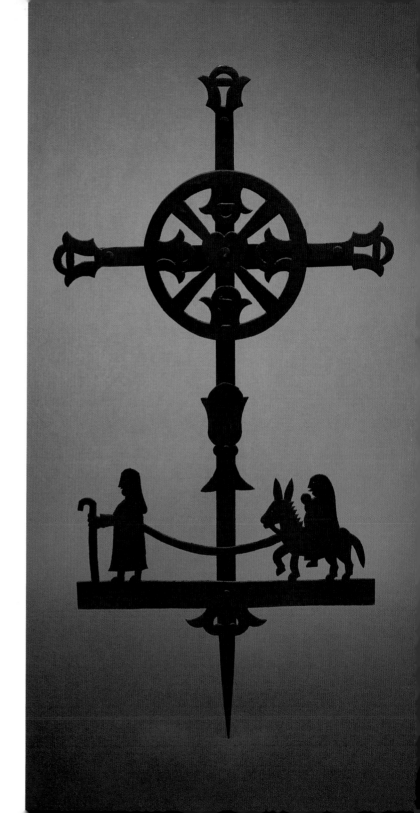

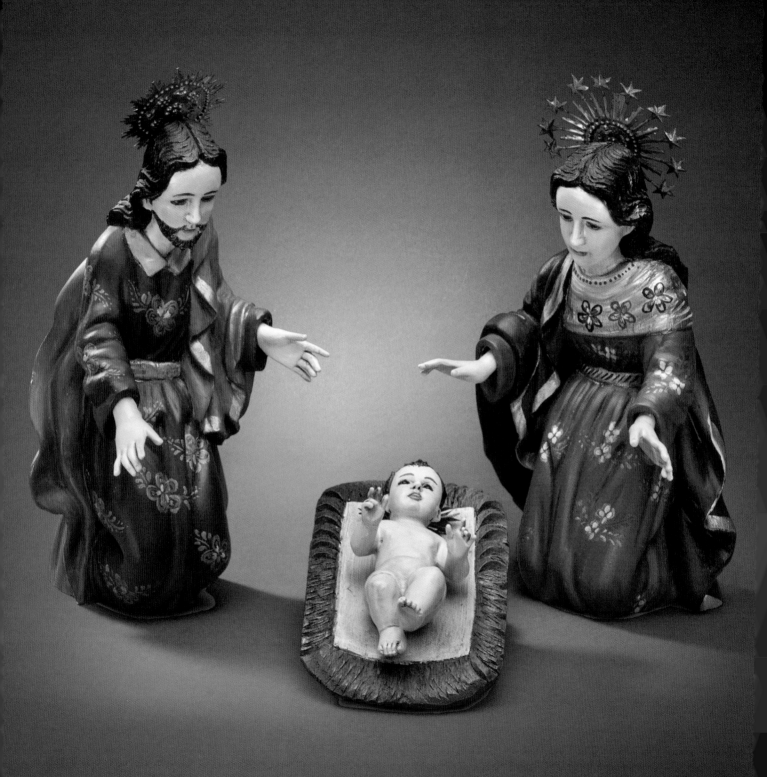

SPANISH COLONIAL REPRODUCTION
NATIVITY FROM QUITO, ECUADOR (2011)

Mary is 9 in. (23 cm.) tall
Susan's Christmas Shop, Santa Fe, New Mexico
PHOTOGRAPH BY BLAIR CLARK

+ +

The country of Ecuador was fabulously rich in religious art during its time as a colony of Spain. The styles used in Ecuador were fashionable in Spain at that time. This rich legacy was carefully documented in the wonderful rare book *Escultura colonial quiteña arte y oficio* by Ximena Escudero Albornoz, which was used to faithfully create this reproduction of a colonial nativity. The book is published in Spanish, but its many fine color photographs make the reader long to travel to Ecuador to see these wonders in person. The hands of Mary and Joseph in this reproduction were carved separately and inserted into the sleeves, where they are held in place by wax. The eyes of all three figures are glass. The bed of baby Jesus is not a reproduction, but simply carved of wood.

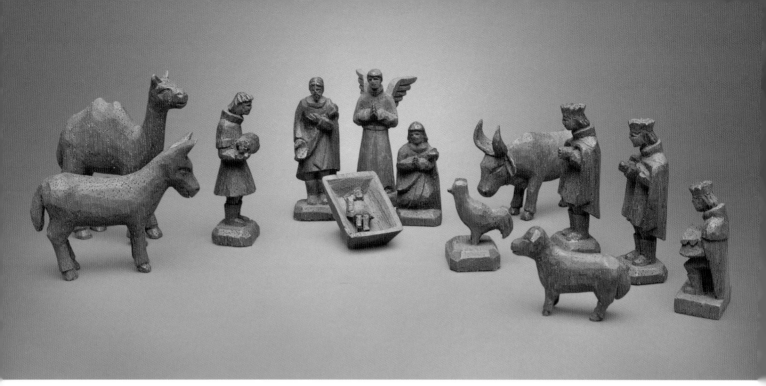

CARVED WOODEN MINIATURE NATIVITY
FROM PARAGUAY (1987)

The tallest figure is 1¼ in. (3 cm.) tall
Private collection
PHOTOGRAPHS BY BLAIR CLARK

+ +

This set has much finely carved detail, considering its small size, and it
also has many wonderful pieces, including several animals. Baby Jesus fits
on an American nickel, which is only ⅞ in. (2.3 cm.) in diameter. A young
Mormon missionary purchased it in Asunción, Paraguay, to give to his
mother. She is a collector of nativities, and this is now one of her special
favorites. The dark wood may be walnut, a wood requiring skill to carve,
especially in this miniature size.

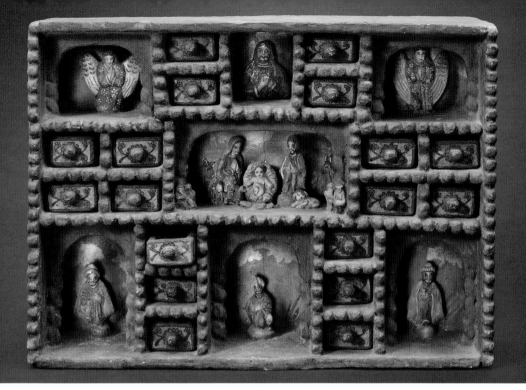

VARGUEÑO NATIVITY BY JAVIER GARCIA FROM AREQUIPA, PERU (1995)

12 in. (31 cm.) wide
Private collection, Albuquerque, New Mexico
PHOTOGRAPH BY BLAIR CLARK

+ +

A *vargueño* is a portable tabletop desk with drawers and compartments. This form of desk was popular in Peru's colonial past. This contemporary miniature *vargueño* serves as the frame for a nativity. The Holy Family is central. Two angels and God or Christ are on the highest level. The three kings are on the bottom level. The drawers actually open, but are too small to hold anything beyond a few piñon nuts. The box itself is made of wood, and the nativity figures are made of potato paste. Potatoes originated in Peru, and the paste is commonly used for figures set into boxes.

HILÁRIO MENDIVIL NATIVITY FROM
CUZCO, PERU (1970s)

The wise men are 20 in. (52 cm.) tall
Author's collection, Santa Fe, New Mexico
PHOTOGRAPH BY BLAIR CLARK

+++

Hilário Mendivil is famous for the distinctive style of his figures, which have very long necks. Hilário's intention was to honor the llama, the animal so vital to life in the high Andes. The materials used are carved, dried maguey (a type of cactus), fabric dipped in gesso, potato paste, and paint. By using draped fabric, Hilário was reviving a colonial technique called *tela encolada*. The wise men ride their elephant, horse, and camel. The surprising difference in scale between the animals and the kings adds to the delight of the scene. Hilário Mendivil died in 1976, but his work is in museums in Spain and the United States. His family in Cuzco continues to create figures in a similar style, but without copying the long necks Hilário loved.

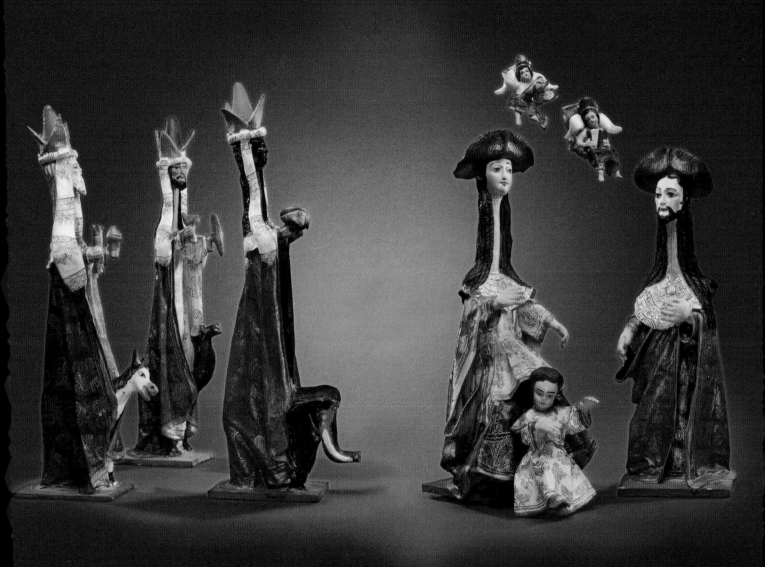

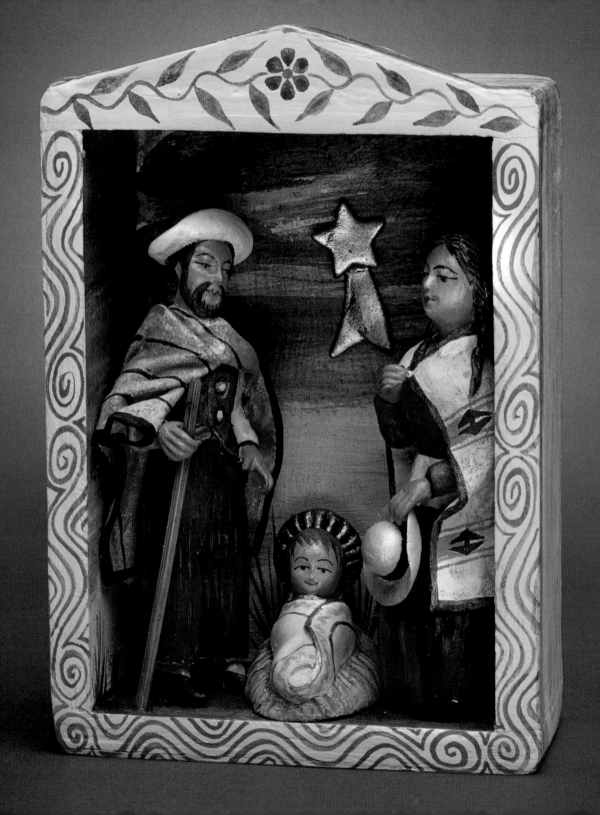

RETABLO NATIVITY BY JAVIER AND PEDRO GONZALEZ FROM A VILLAGE NEAR HUANCAYO, PERU (2011)

6 in. (15 cm.) tall

Private collection

PHOTOGRAPH BY BLAIR CLARK

+ +

In Peru, a *retablo* is often a vertical box holding a scene. Some *retablos* have hinged doors that open to frame the scene. This *retablo* has no doors, and its charming figures are carved of dried maguey wood. Joseph's poncho was made of maguey pounded and pounded until its fibers made a flexible sheet that could be draped like fabric. Mary and Joseph are dressed in classic Andean style, and Joseph holds a staff. There is much more detail to these figures than the typical Peruvian *retablo* figures made of potato paste.

CONTEMPORARY-STYLE CLAY NATIVITY FROM AYACUCHO, PERU (2011)

14½ in. (37 cm.) wide
Private collection
PHOTOGRAPH BY BLAIR CLARK

++

This amazing large and heavy nativity was made completely from clay, including pieces that were rolled, cut, and draped like fabric to form the clothes of Mary and Joseph and the blanket on which the baby Jesus lies. The look of this technique is much more interesting than the slip-cast Peruvian nativities that are now being mass-produced. All the figures wear Andean-style hats and clothing. The little angel plays his music on an Andean-style musical instrument. The sweet faces here are more European and are characteristic of the current fashion in Ayacucho.

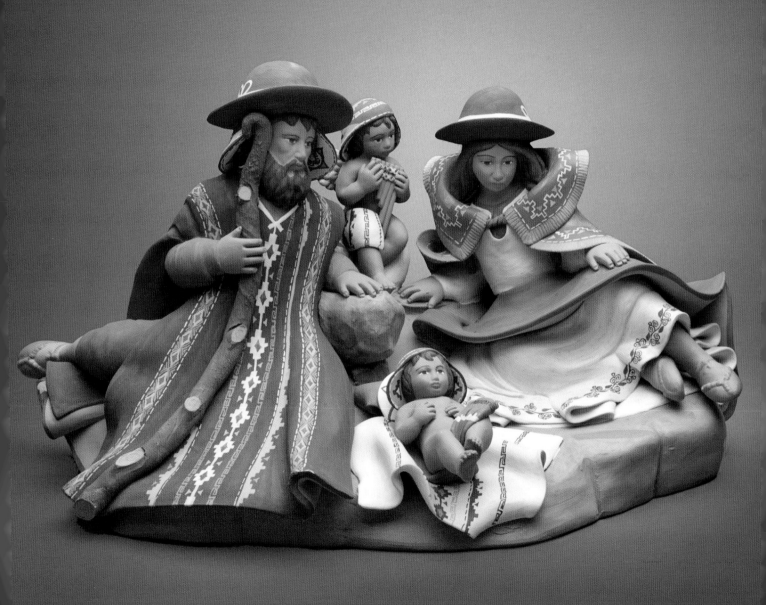

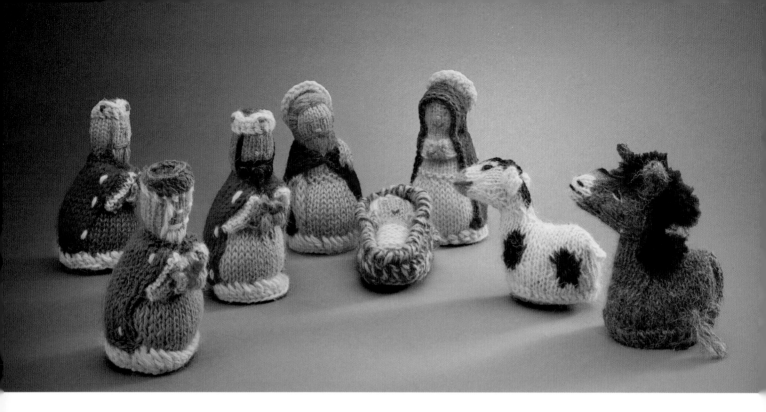

KNIT NATIVITY USING ALPACA YARN FROM PERU (2011)

The tallest figure is 2½ in. (6 cm.) tall
Susan's Christmas Shop, Santa Fe, New Mexico
PHOTOGRAPH BY BLAIR CLARK

+ +

Andean women are accomplished knitters. This design may have been suggested to the knitters by an importer seeking a product to sell. The result is a delightful handmade nativity suitable for a small child to touch without fear of breaking. The yarn is made of the soft fleece of the alpaca. Traditional Andean women, using two knitting needles and a bit of embroidery, achieve an amazing amount of detail in very small nativity figures for a very affordable price.

SOFT SCULPTURE NATIVITY STOCKING FROM LIMA, PERU (2011)

20 in. (50 cm.) tall
Private collection
PHOTOGRAPH BY BLAIR CLARK

+ +

This Christmas stocking shows a nativity scene made using soft sculpture, appliqué, and embroidery. It was made by a cooperative of Andean women living in the shantytowns on the outskirts of Lima. Lima is like a magnet to the poor of the high Andes of Peru, and they often move there in search of work. A German nun, so the story goes, taught some of the women to do this kind of work, thus providing them a way to earn money. No two are ever alike, and not all are nativity scenes, but the nativity theme is popular.

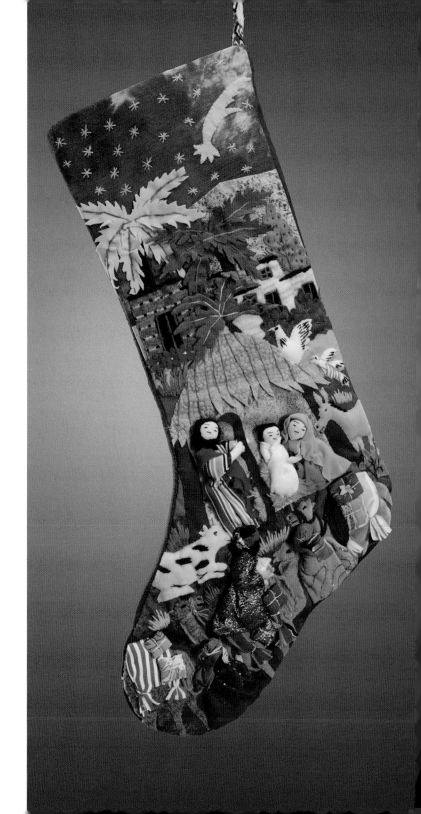

MINIATURE CARVED STONE *RETABLO* FROM PERU (1988)

2½ in. (6 cm.) tall
Author's collection, Santa Fe, New Mexico
Photograph by Blair Clark

+++

This white stone is called *piedra de huamanga* in Peru. Slabs of this stone were sometimes used as church windows in the colonial days, and the stone acquired a waxy translucence as centuries passed. Unfortunately, these have now been replaced with modern stained glass. *Piedra de huamanga* is relatively soft. This *retablo* is quite small and well carved. The stone doors don't close, but they do frame the two scenes very nicely. The nativity is on the upper level, and a shepherd and his animals are on the lower level.

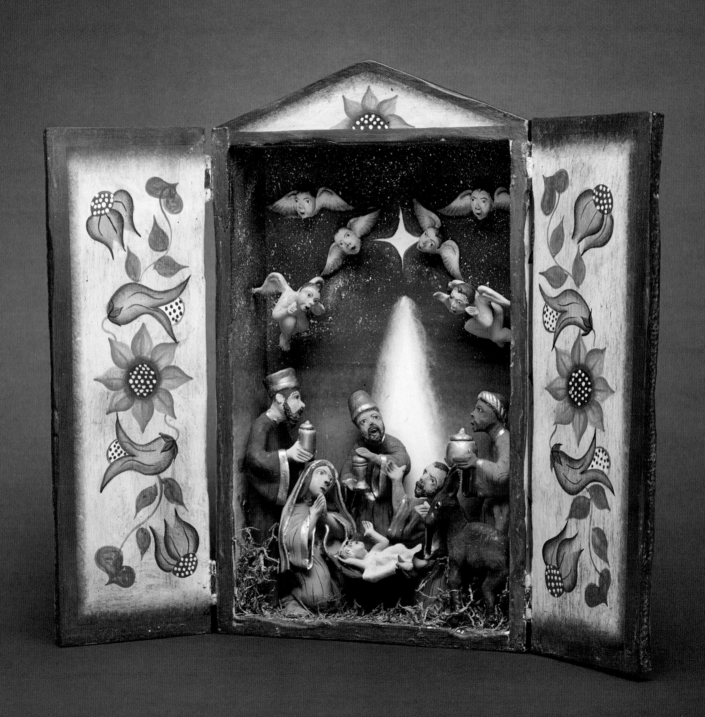

NATIVITY *RETABLO* WITH DOORS BY JAIME GALVEZ OF AYACUCHO, PERU (2011)

15 in. (39 cm.) tall

Collection of Anne Ritchings, Placitas, New Mexico

PHOTOGRAPH BY BLAIR CLARK

+++

This Peruvian *retablo* with doors has an original style. Dried potato and liquid make the paste used to form the figures. The figures are large, and have distinctive gestures. The wise men hold their gifts. Two of the angels seem to float above the nativity scene. Baby Jesus appears to see them and reach for them. The hinges are simply pieces of leather. When a *retablo* has doors, it is always possible to close the doors till Christmas morning, adding a special drama to the day.

MIDDLE EAST

CARVED SHELL NATIVITY FROM
BETHLEHEM, ISRAEL (2000)

6½ in. (17 cm.) wide
Collection of Mary Ann Adams,
Albuquerque, New Mexico
PHOTOGRAPH BY BLAIR CLARK

+ +

Mother-of-pearl was carved to make this detailed nativity scene. The
principal figures are each carved separately, and they stand on a nar-
row ledge. Their clothes are so detailed that the drapery of the fabric is
carved, a delicate border was created, and a filigree section below the
ledge features a second star. So proud of his accomplishment was the
carver that he added a name, Rosses, below the baby Jesus.

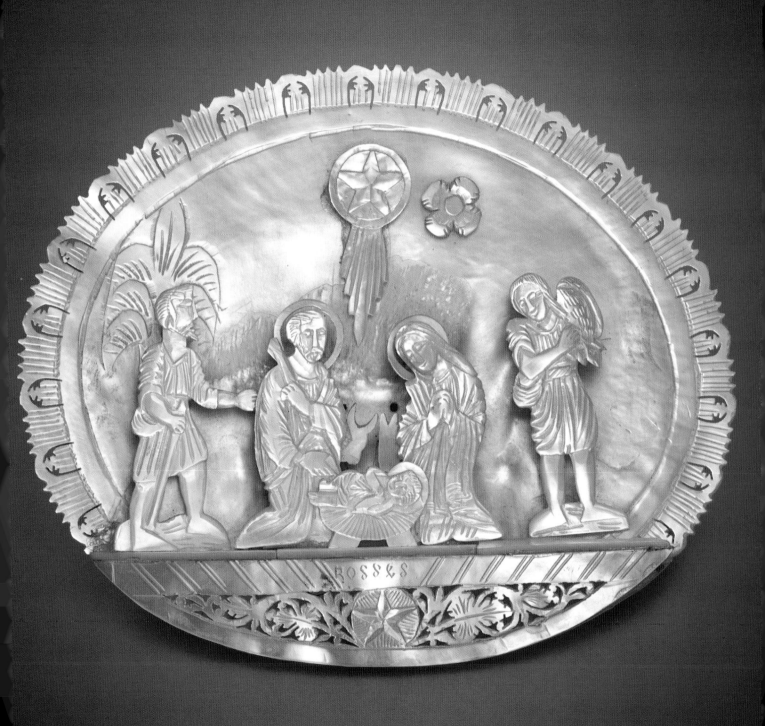

AFRICA

CARVED WOODEN NATIVITY FROM
BURKINA FASO (2004)

The tallest figure is 10½ in. (27 cm.) tall
Collection of Max and Joyce Douglas, Denver, Colorado
PHOTOGRAPH BY RANDY MACE

++

This African set is clothed in the Christian colonial style of suits, ties, and hats. Mary is dressed as a bride. Joseph is the seated figure, elegantly crossing his legs. Baby Jesus is dressed in a white suit and also wears a hat. The central figure in yellow is an angel. They are all well dressed for the occasion. There is only one animal, a small sheep attached to the shepherd, but the set is distinctive. It represents a culture far, far away from most of the readers of this book.

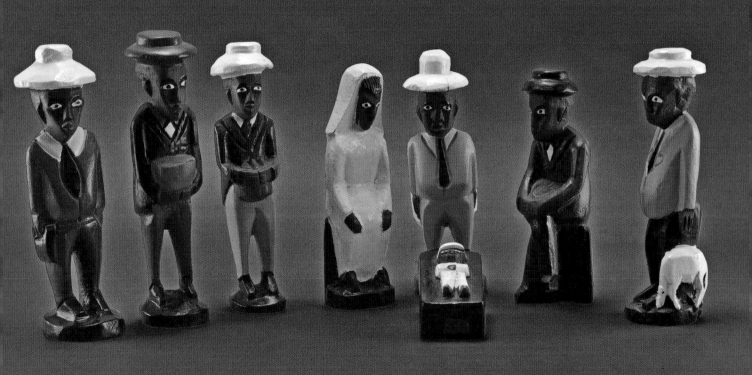

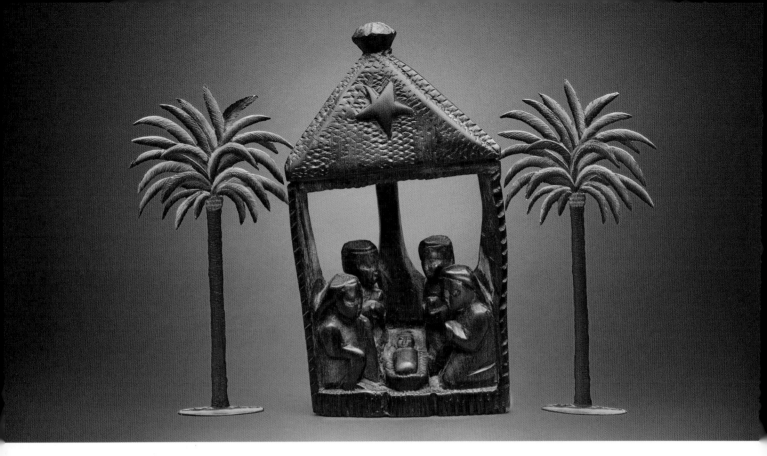

CARVED WOODEN NATIVITY FROM ZIMBABWE (2005)

9 in. (23 cm.) tall
Private collection
PHOTOGRAPH BY BLAIR CLARK

+ +

A single block of wood was used to carve this distinctive nativity. A dark stain was applied in some places for contrast. The star is on the pitched roof of the hut, which can be lifted by its finial. The palm trees are German pewter, an accessory that adds color to the scene and also symbolizes Bethlehem.

STONE SCULPTURE BY TAYLOR NKOMO OF ZIMBABWE (2004)

13 in. (33 cm.) tall
Collection of Max and Joyce Douglas,
Denver, Colorado
PHOTOGRAPH BY RANDY MACE

+++

Zimbabwe's landscape is covered with stones. The name *Zimbabwe* means "stone houses." A workshop led by Joram Mariga in 1958 introduced sculpting techniques for stone to Zimbabwe. Since then, emerging artists have become accomplished sculptors, and their work has been exhibited in Europe and the United States. This stone nativity was commissioned from the artist while he was a resident stone carver at the Denver Botanic Gardens. The nativity is sculpted from a single stone, and then carefully polished.

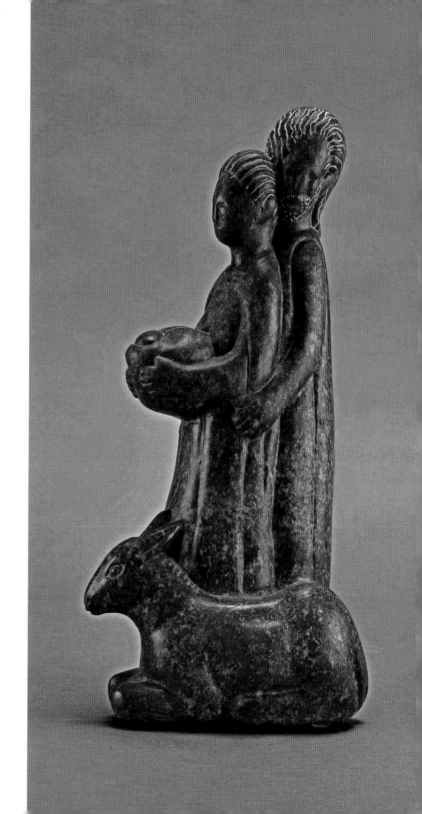

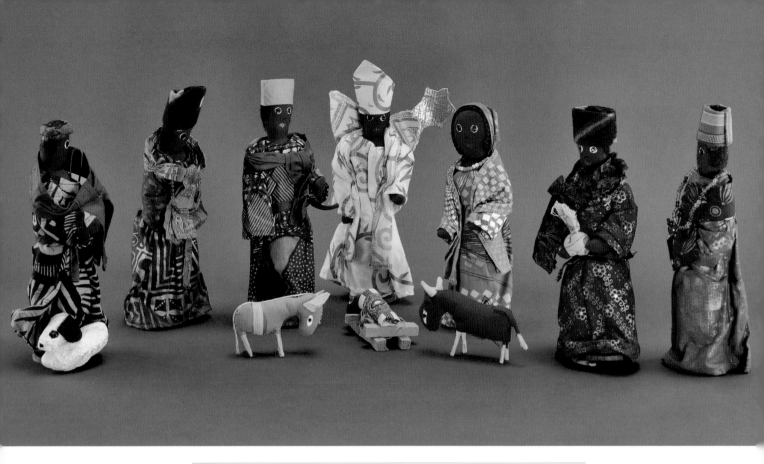

AFRICAN FABRIC NATIVITY FROM AN
UNIDENTIFIED AFRICAN COUNTRY (2004)

The tallest figure is 10 in. (26 cm.)
Collection of Max and Joyce Douglas, Denver, Colorado
PHOTOGRAPH BY RANDY MACE

+++

Distinctive, colorful African fabrics adorn each figure of this nativity,
giving it an unmistakable identity of that continent, even if the specific
country of origin remains to be discovered. A few beads make a necklace
for Mary. The kings wear crowns and bear gifts. The animals are much too
small to be real, but consistency of scale seldom matters in ethnic folk
art nativities.

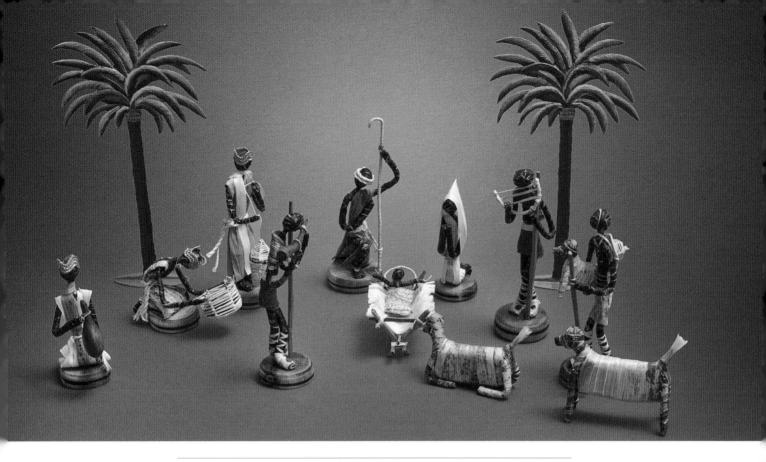

BANANA LEAF FIBER NATIVITY FROM KENYA (2003)

The tallest figure is 5 in. (12 cm.)
Collection of Mary Ann Adams, Albuquerque, New Mexico
PHOTOGRAPH BY BLAIR CLARK

+ +

The anonymous gifted artisan in Kenya who made this nativity was able to capture African postures and gestures with such accuracy that these figures look like they could move when we look away. Simple banana leaf fiber was used, but the details, such as the kings' crowns, their gifts, and the elaborate sandals of the shepherds, are all admirable. Round wooden bases add stability to the figures. The two painted German pewter trees add color.

ASIA

FOLDING WHEAT STRAW NATIVITY FROM BANGLADESH (2004)

7 in. (18 cm.) tall

Collection of Max and Joyce Douglas, Denver, Colorado

PHOTOGRAPH BY RANDY MACE

+ +

This novel nativity folds like a book and can be closed by a snap, so it is similar to a portable altar to take when one is traveling. To make this scene, wheat straw was flattened, glued onto cardboard, stained, cut out, and assembled inside a fabric cover.

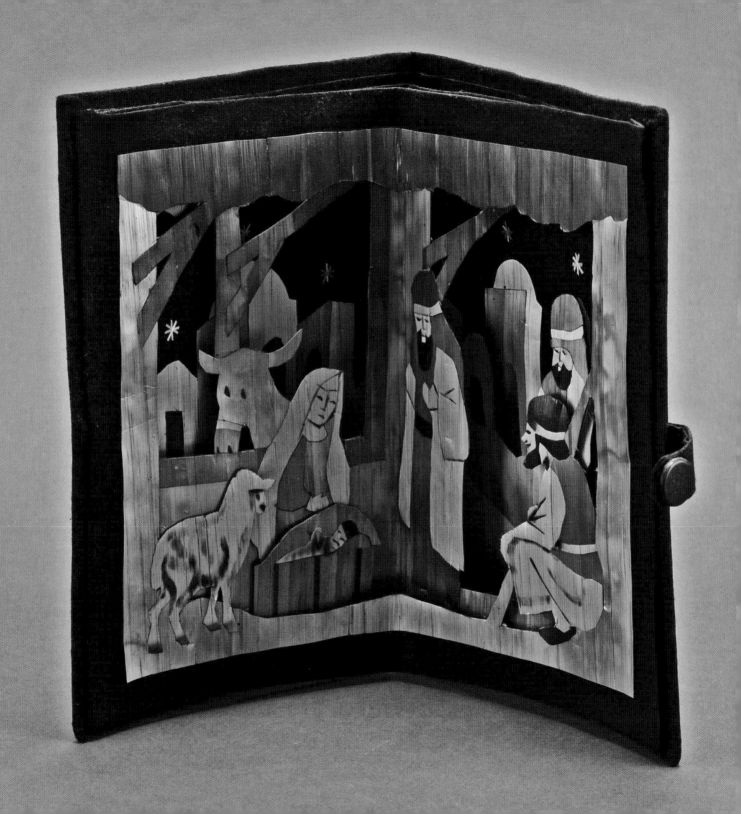

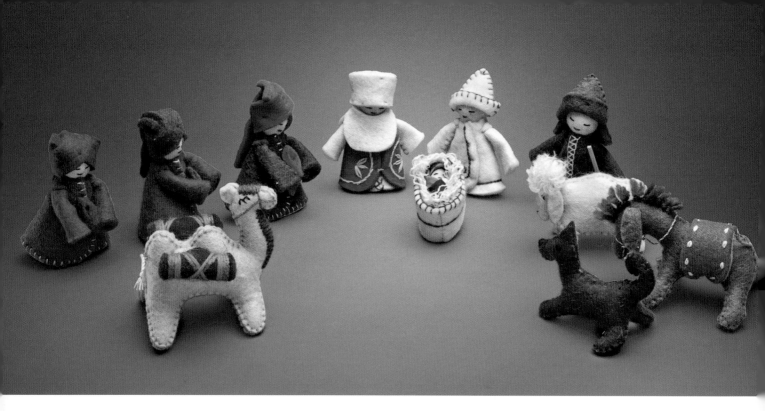

FELT NATIVITY FROM KAZAKHSTAN (2005)

The tallest figure is 2½ in. (6 cm.)
Private collection, Corrales, New Mexico
PHOTOGRAPH BY BLAIR CLARK

+ +

The nomadic people of Kazakhstan live in tents called yurts and they move often. They make their own felt from sheep's wool, then dye it bright colors, cut it, and stitch it into figures. Since the climate can be cold, all the figures are warmly dressed and wear hats. The camels of their nativities are not a creation of the imagination: they actually live and work in Kazakhstan. This was purchased in Kazakhstan directly from the maker. The Santa Fe International Folk Art Market, which is held annually in mid-July, usually offers similar felt figures from Kyrgyzstan.

PRINTING BLOCK NATIVITY FROM INDIA (2011)

The tallest figure is 2½ in. (6 cm.)
Susan's Christmas Shop, Santa Fe, New Mexico
PHOTOGRAPH BY BLAIR CLARK

++

Copper strips are hammered into simple blocks of wood, cut to suggest the shapes of nativity figures. Theoretically one could actually print with these blocks. The copper can be made to appear brighter by a light sanding with sandpaper. Nativities from India are not very common.

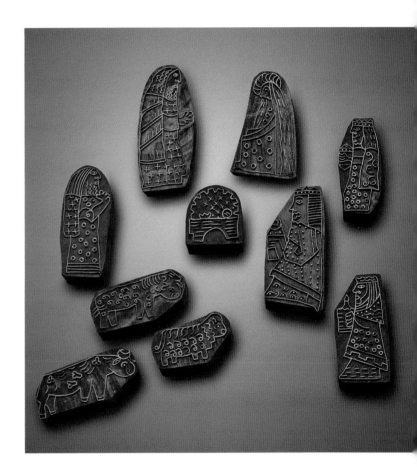

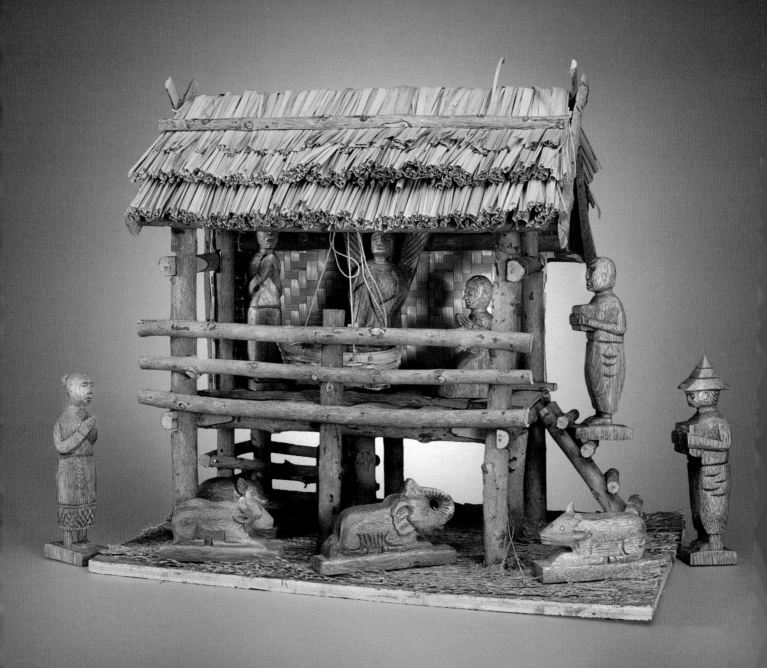

TWO-STORY STABLE NATIVITY FROM LAOS (1980s)

12 in. (31 cm.) tall
Susan's Christmas Shop, Santa Fe, New Mexico
(from the estate of a collector)
PHOTOGRAPH BY BLAIR CLARK

+++||||||||||||||||+++++++++++++++++++++

In Laos, the people live above and the animals live below. This two-story stable demonstrates that arrangement. Baby Jesus lies in a hanging cradle that can be pushed to rock the baby. There is no doubt that this nativity is from Laos, but an identical stable appeared in another book holding a carved wooden nativity from Zimbabwe, suggesting that stables can be adopted for use with another country's figures on occasion.

UNITED STATES

SPANISH COLONIAL-STYLE NATIVITY BY DAVID NABOR LUCERO (2011)

Joseph is 4 in. (10 cm.) tall
Private collection
PHOTOGRAPH BY BLAIR CLARK

+ +

David Nabor Lucero is a *santero* in Santa Fe, New Mexico. A *santero* makes religious images. Nabor works in a style called Spanish colonial. When the Spanish colonists were completely isolated on the farthest frontier of New Spain, they had to make their own religious images, and this style evolved. The figures are first hand carved out of wood. Then they are covered with a gesso, which Nabor makes out of hide glue and gypsum. Next he paints them with colorful earth pigments his wife grinds for him. Then the figures are coated with varnish made of piñon. Finally, they are coated with pure beeswax. Nabor often wins prizes for his work at the two annual Spanish Markets in Santa Fe. A major, large-scale nativity by Nabor and his brothers was commissioned by the Santa Maria de la Paz Catholic Community, where it is put on public display shortly before Christmas. Photos of this nativity are in the author's book *Christmas in Santa Fe*.

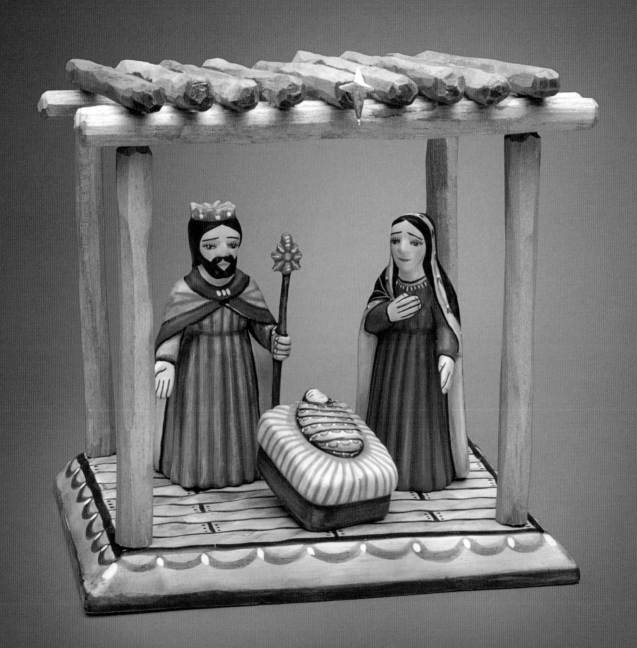

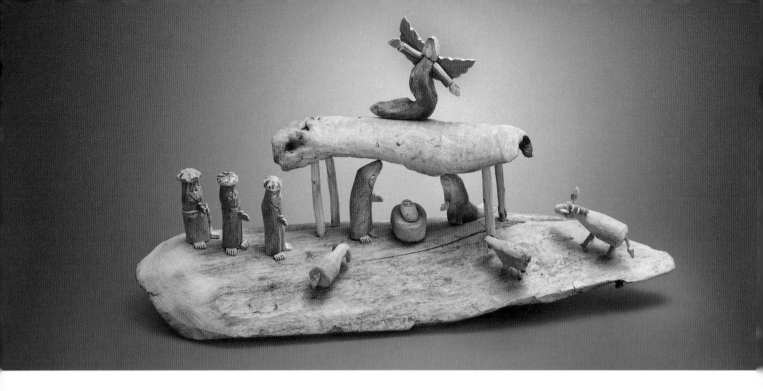

DRIFTWOOD NATIVITY BY DAVID AND LOUISE ALVAREZ (1995)

14 in. (36 cm.) long
Collection of Mary Ann Adams, Albuquerque, New Mexico
PHOTOGRAPH BY BLAIR CLARK

+++

Husband and wife team David and Louise Alvarez collected driftwood from the shores of New Mexico lakes. Back at their studio in Agua Fria, New Mexico, they cut and carved the wood, adding hands for the figures, wings for the angel, and feet and legs for the sheep. An angel is always pegged into the top of their nativity stables. This was the very first nativity they made together, and it includes a donkey. David was inspired by a nativity his father-in-law, Ben Ortega, had made. Ortega was a famous folk artist from Tesuque, New Mexico, who died in 2010. Louise continues to make wonderful nativities and angels, and now signs them with her maiden name, Ortega.

BAKED SALT DOUGH NATIVITY ORNAMENTS BY SUSAN TOPP WEBER (2009)

Joseph is 3 in. (8 cm.) tall
Author's collection, Santa Fe, New Mexico
PHOTOGRAPH BY BLAIR CLARK

+ +

The author's hand-formed, baked nativity composed of six salt dough ornaments was in a national juried show at the Renwick Gallery in Washington, D.C., in 1975. The Renwick is a branch of the Smithsonian dedicated to crafts. The show was called Craft Multiples, and was designed to show production crafts in the United States at the time of the bicentennial. Everything in the show was purchased for the permanent collection of the Smithsonian. The author began making ornaments in 1969, and still makes them to sell in her shop, Susan's Christmas Shop in Santa Fe. The ornaments in this photo are like those in the Smithsonian, but were made by the author in 2009.

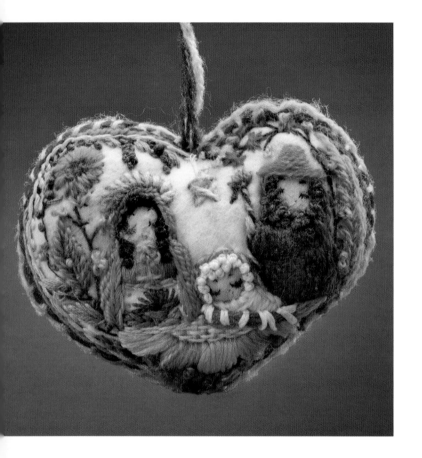

EMBROIDERED NATIVITY AND HEART BY ANN MILLS OF SANTA FE, NEW MEXICO (1960s)

The figures are 5 in. (13 cm.) tall; the heart is 3½ in. (9 cm.) wide
Collection of Mary Ann Adams, Albuquerque, New Mexico (except for the heart, which is from a private collection, Los Alamos, New Mexico)
PHOTOGRAPHS BY BLAIR CLARK

++

Ann Mills was famous for her colorful embroidered pieces in the 1950s through 1970s, when her work was sold at Suzette's Boutique in Santa Fe. She also designed kits for others to complete. This complete embroidered nativity is Ann's original design. There are many pieces to the set, each one carefully embroidered by hand. The lovely embroidered heart ornament is also Ann's distinctive, unmistakable work. Ann's work is prized by collectors, and a book about her is being written.

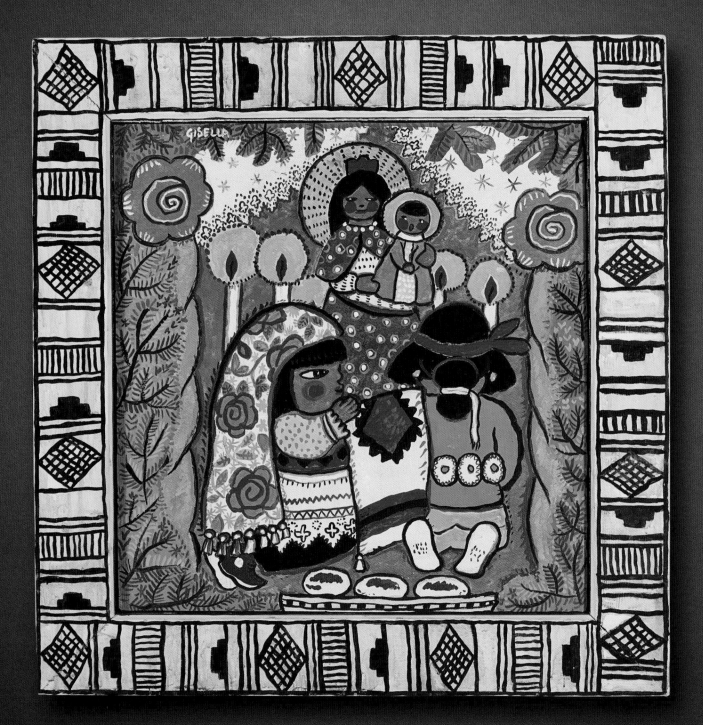

PAINTING BY GISELLA LOEFFLER OF TAOS, NEW MEXICO (1950s)

28 in. (72 cm.) square
Private collection, Santa Fe, New Mexico
PHOTOGRAPH BY BLAIR CLARK

+ +

Gisella Loeffler was born in Austria in 1900, but moved to St. Louis, Missouri, as a small child. In 1933, she divorced her husband and moved to Taos, New Mexico, with her daughters and became part of the local art scene. That was a wonderful time to be there. She was known for her colorful clothing, her colorful house, and her colorful paintings of young pueblo children. This delightful large nativity painting features those children, all dressed up and kneeling in front of a Madonna and child, perhaps in an outdoor shrine, supported with the carved columns found in Taos and fresh evergreen boughs. Gisella also designed and painted the frame for this painting, which was her usual custom.

FLIGHT INTO EGYPT BY ARMANDO LOPEZ OF ABIQUIU, NEW MEXICO (2001)

24 in. (62 cm.) tall
Collection of Suzy O'Neill, Santa Fe, New Mexico
PHOTOGRAPH BY BLAIR CLARK

+ +

This dramatically large Flight into Egypt is made of wire, metal, and natural materials. The angel holds a lantern in front of the donkey carrying Mary and baby Jesus to safety, and Joseph brings up the rear to protect them. Distinctive work like this is sold in galleries rather than gift shops, and the artist is now painting oil paintings in addition to building large angels and Madonna figures. His studio can be seen during the Abiquiu Studio Tour each October.

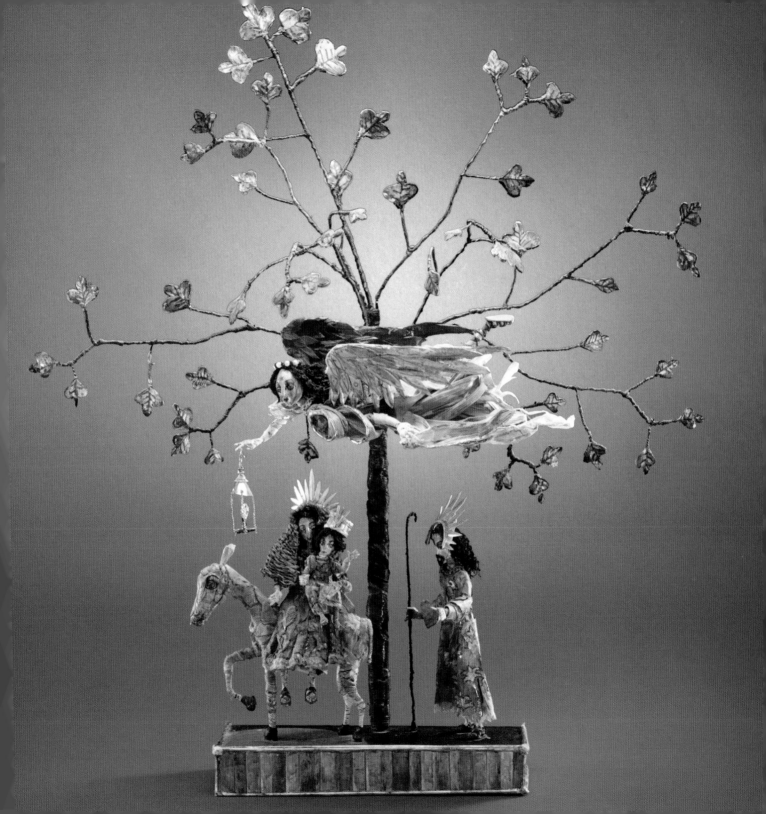

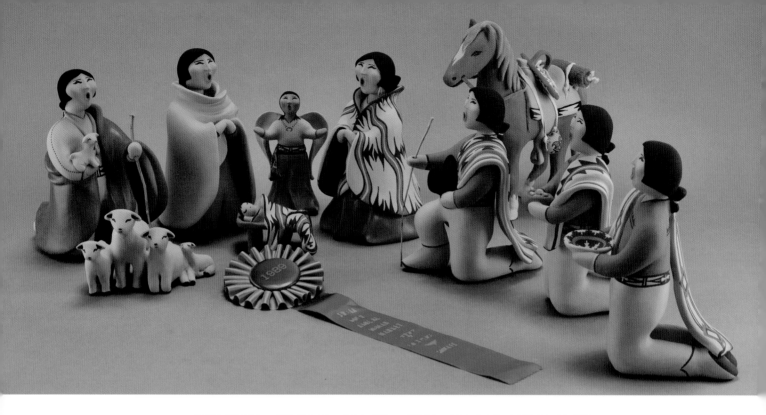

PUEBLO POTTERY NATIVITY BY ROSE PECOS
FROM JEMEZ PUEBLO, NEW MEXICO (1989)

The figures are 8½ in. (21 cm.) tall
Collection of Max and Joyce Douglas, Denver, Colorado
PHOTOGRAPH BY RANDY MACE

+ +

This large pottery nativity of native clay from Jemez Pueblo won a first
prize blue ribbon at the 1989 Indian Market in Santa Fe. It is unusual in all
the details, like the horse's trappings, the painted designs on the blankets,
the painted belts, the traditional pueblo hairstyles, and the sections that
shine because they were burnished with a smooth stone prior to firing.
The four sheep are one piece, an interesting innovation. All the figures
seem to be singing.

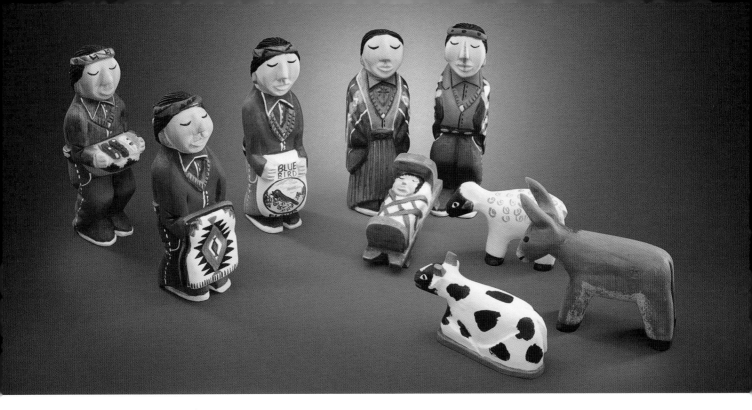

NAVAJO CARVED WOODEN NATIVITY BY HARRY AND ISABELLE BENALLY OF SHEEP SPRINGS, NEW MEXICO (1995)

The figures are 7 in. (18 cm.) tall
Collection of Suzy O'Neill, Santa Fe, New Mexico
PHOTOGRAPH BY BLAIR CLARK

+ +

Blue Bird Flour is a brand favored on the Navajo Reservation, so a sack of this flour is one of the gifts these Navajo wise men bring. Harry carved the figures of native woods. Then they were sanded and painted with acrylic by his wife, Isabelle. All the details of the clothing are authentic Navajo style, including the headbands on the men, the white-soled, rust-colored moccasins, the jewelry, the colorful shirts, Joseph's blue jeans, and baby Jesus on a traditional Navajo cradleboard.

NAVAJO PICTORIAL RUG BY LINDA NEZ (2000)

36½ in. (93 cm.) tall

Collection of Max and Joyce Douglas, Denver, Colorado

PHOTOGRAPH BY BLAIR CLARK

+ +

Hand-woven Navajo rugs take a long time to weave, and detailed pictorial rugs may take months to finish. Skilled pictorial weavers like Linda Nez can get high prices, or what sounds high until you count the hours of work involved. Sheep must be tended and then they must be sheared. The wool must be cleaned, carded, and spun into yarn before coming to the weaver's loom. Linda Nez has woven several nativity rugs, all of them different. This one features two camels, several sheep, chickens, birds, and butterflies, all achieved on a traditional Navajo loom. Weavings like this do not lie on the floor to be walked on. Instead, they are displayed on a wall like a prestigious work of art.

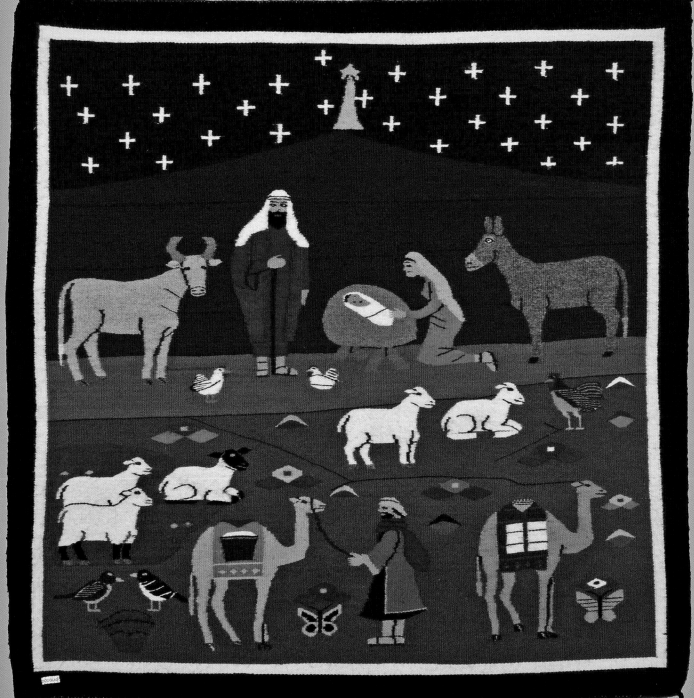

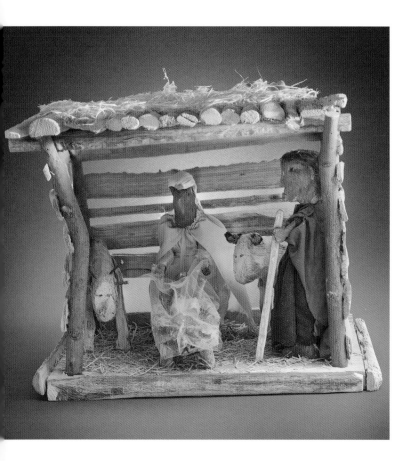

PAPAGO NATIVITY BY CHEPA FRANCO (1986)

The stable is 6 in. (15 cm.) tall
Collection of Mary Ann Adams,
Albuquerque, New Mexico
PHOTOGRAPH BY BLAIR CLARK

+ +

The Tohono O'odham are an American Indian people who live in the desert of southern Arizona. When this nativity was made, they were known as the Papago. Domingo and Chepa Franco, husband and wife, were the first of their tribe to make nativities in the 1960s. Domingo died in 1966. When Chepa Franco made this simple wooden nativity in 1986, she was 85 years old, and died just a few months later. Some of the materials she used to make this nativity are saguaro ribs. Saguaro ribs are the skeleton of the giant cactus found on the Tohono O'odham reservation, and are salvaged after the saguaro falls to the floor of the desert at the end of its long life. Tall saguaro cacti grow arms that rise toward the sky, but they are typically at least 60 years old before the arms begin to grow. Saguaro are revered by the Tohono O'odham.

ACOMA PARROT NATIVITY BY CHRIS THOMAS OF SANTA FE, NEW MEXICO (2003)

5 in. (13 cm.) tall
Private collection, Santa Fe, New Mexico
PHOTOGRAPH BY BLAIR CLARK

+ +

Chris Thomas was a talented artist who loved doing miniature work. His mother is from Laguna Pueblo and his father is Pima. Chris was a graduate of the highly regarded St. Catherine's Indian School in Santa Fe and Fort Lewis College in Durango, Colorado. He was a sophisticated designer, familiar with many Indian design elements. Chris lived in Santa Fe and created unique small scenes. Before his untimely death in 2005, he made over 50 small nativities designed to hang on a wall. This one uses Acoma Pueblo pottery designs to frame a pueblo nativity carved of wood and carefully painted with traditional designs. The author is hoping to find more Chris Thomas nativities for a future book.

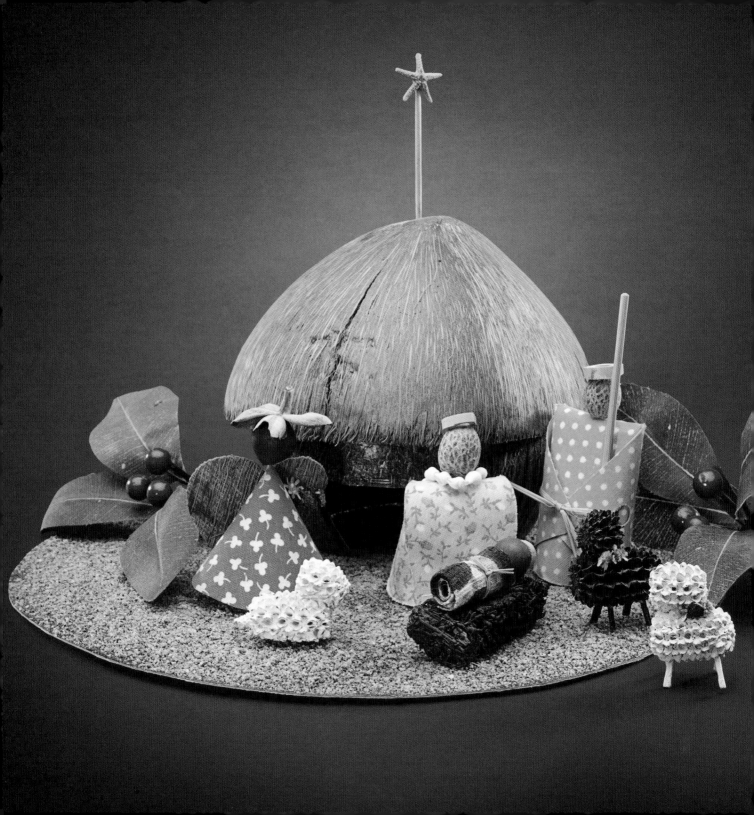

HAWAIIAN NATIVITY (1980)

The height to the star is 6 in. (15 cm.)
Collection of Ann Reynolds Smith, Santa Fe, New Mexico
PHOTOGRAPH BY BLAIR CLARK

+++

The women of Holy Innocents Episcopal Church in Lahaina, Maui, made nativities out of natural materials to sell at their church bazaar around 1980. The stable is a coconut. The star above the stable is a tiny starfish. This set was purchased 30 years ago, but it remains the favorite nativity set of its owner.

NOVELTY NATIVITIES

WINE BOTTLE CORK NATIVITY BY SUZY O'NEILL (2011)

The stable is 8 in. (20 cm.) tall at the star
Collection of Suzy O'Neill, Santa Fe, New Mexico
PHOTOGRAPH BY BLAIR CLARK

++

When creativity and an urge to collect are found in the same person, unusual nativities can result. Several nativities from Suzy O'Neill's collection are photographed in this book. This one Suzy invented and made herself. All the figures are made of corks saved from bottles of wine. The wise men are made of champagne corks, and their crowns are the caps of beverages whose lids feature stars. This nativity is a lighthearted addition to a collection Suzy takes seriously, a distinguished collection that her friends enjoy in her Santa Fe home at Christmas.

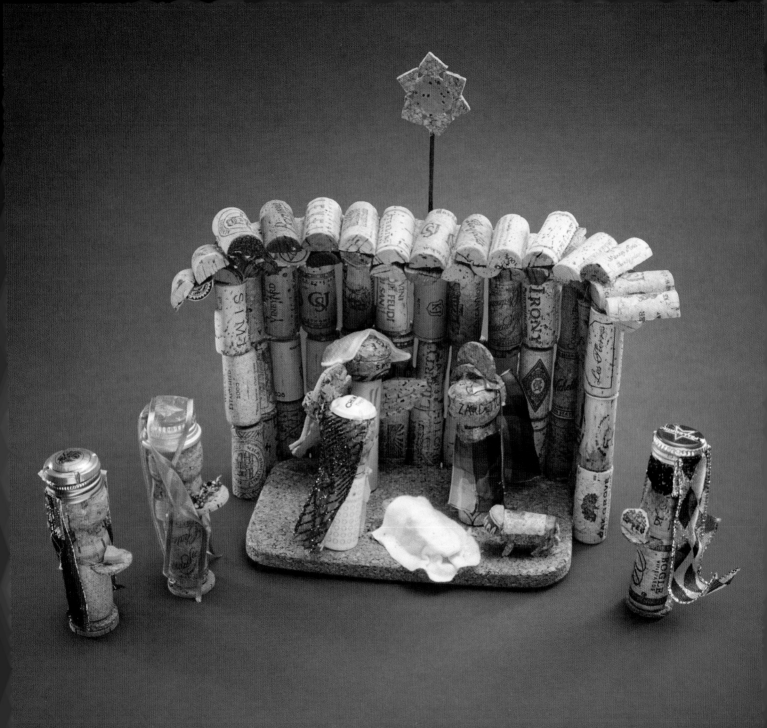

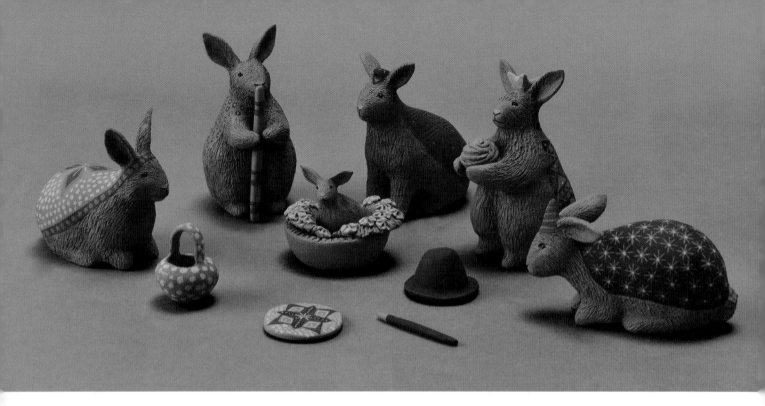

POTTERY BUNNY NATIVITY FROM CASAS GRANDES, MEXICO (2005)

The tallest figure is 4 in. (10 cm.)
Collection of Max and Joyce Douglas, Denver, Colorado
PHOTOGRAPH BY RANDY MACE

+ +

Animal nativities may not always please everyone, but this bunny nativity set is quite sweet. One of the wise men seems to be bringing a cabbage as his gift. Casas Grandes is close to the border with the United States, and in recent years has become known for its innovations in pottery design. This is an innovation.

STERLING SILVER NATIVITY SPOON (19TH CENTURY)

6 in. (15 cm.) long
Collection of Mary Ann Adams,
Albuquerque, New Mexico
PHOTOGRAPH BY BLAIR CLARK

+ +

Sterling silver souvenir spoons were popular and collectible in the late nineteenth century. This one has a four-leaf clover symbol stamped on the back. The Santa in the chimney is of a late nineteenth-century style. The lettering in the bowl of the spoon reads, "PEACE ON EARTH, GOOD WILL TOWARD MEN." The spoon is in such good condition that it was likely never used for anything except admiration.

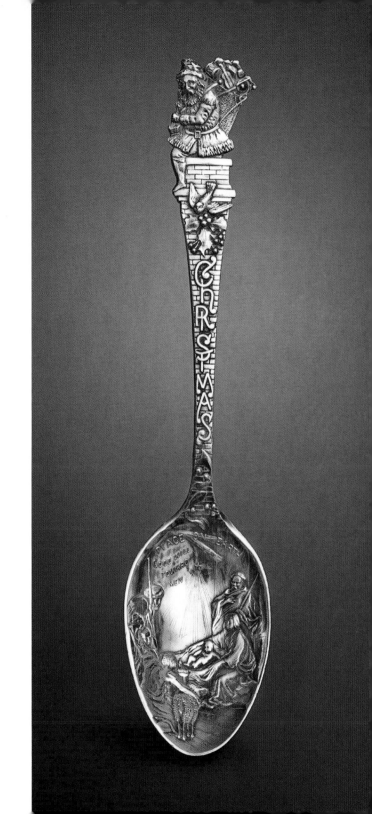

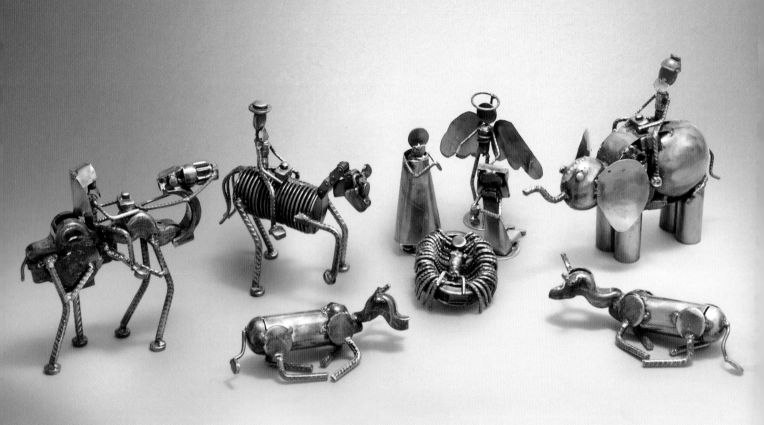

RECYCLED METAL NATIVITY BY ARMANDO RAMIREZ OF GUADALAJARA, MEXICO (2007)

The tallest figure is 9 in. (23 cm.)
Collection of Mary Ann Adams,
Albuquerque, New Mexico
PHOTOGRAPH BY BLAIR CLARK

+ +

Discarded automobile and bicycle parts were used to make this unusual nativity. The figures of the wise men are especially creative, riding an elephant, a horse, and a camel. Baby Jesus's body is a spark plug. It must have been fun to make this delightfully detailed nativity.

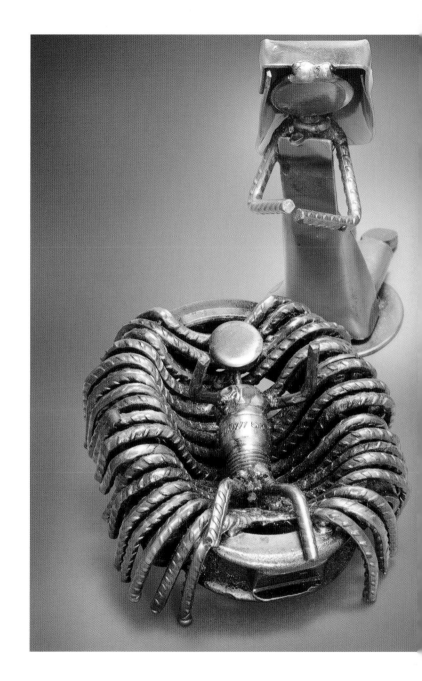

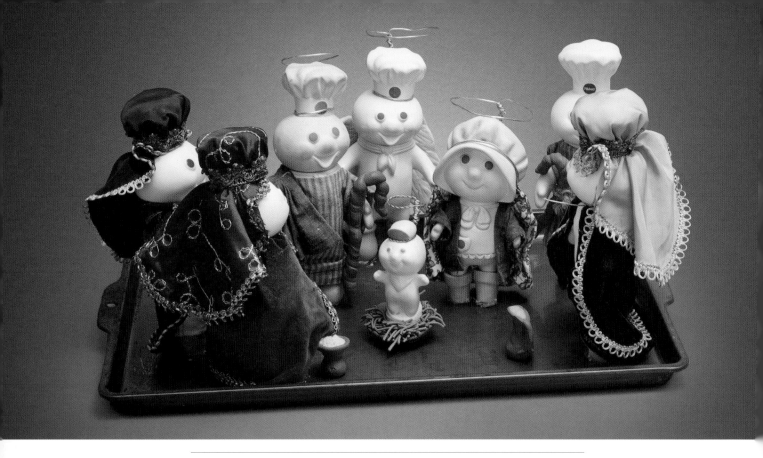

THE PILLSBURY DOUGHBOY NATIVITY
(A FAMILY COLLABORATION) (2002)

The baking sheet is 14 in. (36 cm.) long
Collection of Mary Ann Adams, Albuquerque, New Mexico
PHOTOGRAPH BY BLAIR CLARK

+++

This nativity was spontaneously invented when a baby Pillsbury Doughboy
was found. Family members conspired to assemble this unique set as a
gift for their mother's nativity collection. A family member made the cos-
tumes. The nativity is set on a baking sheet, which is part of the joke. This
set is of great sentimental value to the collector's family, and it is the only
Pillsbury Doughboy nativity in the world.

"THE FROGTOWN PLAYERS PRESENT THE NATIVITY SCENE," DESIGNED BY KITTY CANTRELL (2005)

The tallest figure is 6 in. (15 cm.)
Collection of Mary Ann Adams, Albuquerque, New Mexico
PHOTOGRAPH BY BLAIR CLARK

+ +

The human appetite for novelty has resulted in some oddities, such as this. This nativity was a gift to a collector, and its owner remarked, "It grows on you." If it makes you smile while it does that, perhaps that is its saving grace. The initials that spell "frog" have recently acquired a special religious meaning, and those people who know that meaning now enjoy making gifts of frog items to their friends.

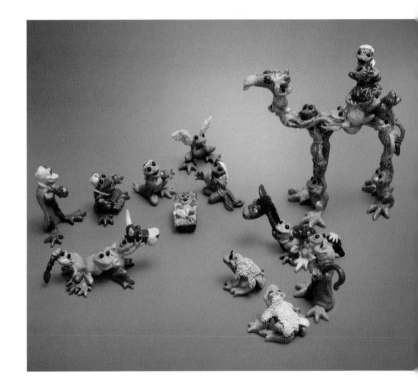

KITCHEN MATCH NATIVITY FROM
OAXACA, MEXICO (2003)

2½ in. (6 cm.) tall (believe it or not!)
Private collection, Colorado Springs, Colorado
PHOTOGRAPH BY BLAIR CLARK

+++

This amazing tiny nativity is set on the end of a common kitchen match.
Ricardo Hernandez Lopez carved the nativity using sharp razors. The
finished nativity is displayed under a tall, narrow glass dome. The skilled
photographer, Blair Clark, was able to make the glass dome disappear, a
bit of magic in itself. The artist sometimes comes to sell his work at the
Santa Fe International Folk Art Market, which is held annually in mid-July.

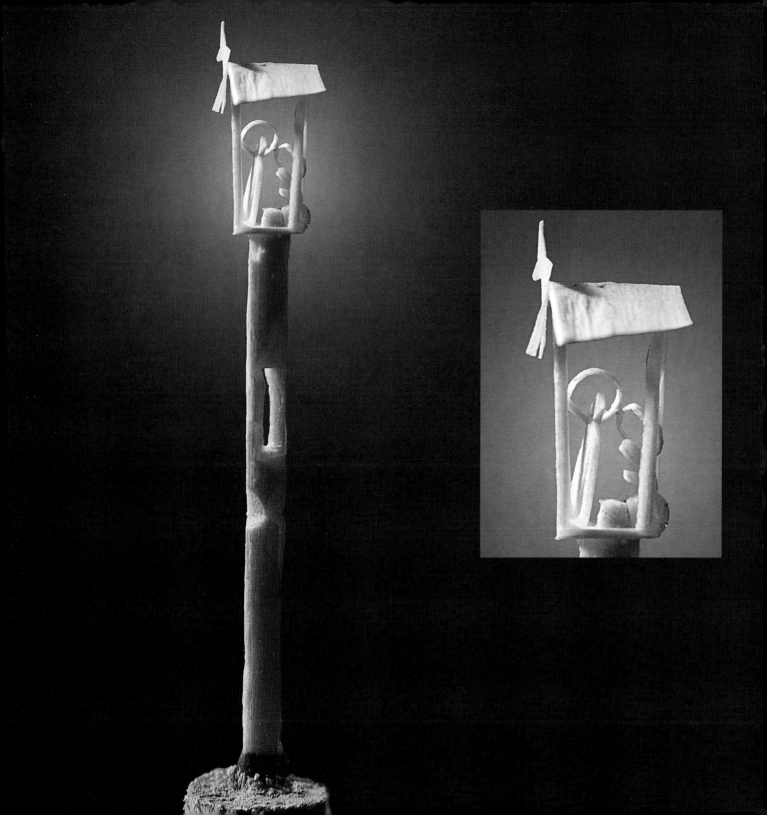

APPENDIX

A GUIDE TO NATIVITY DISPLAYS AROUND THE WORLD

COMPILED BY JUDITH DAVIS OF FRIENDS OF THE CRECHE

This guide contains only the most highly rated displays. There are many, many more that can be seen. For a more complete list, visit the Web site of Friends of the Creche (www.friendsofthecreche.org), a national American organization dedicated to nativities.

There is also an international world association of nativities, UN-FOE-PRAE, an abbreviation for Universalis Foederatio Praesepistica. The organization was founded in Barcelona, Spain, in 1952 with representatives from seven national nativity associations. Currently it includes 19 national nativity clubs from Europe and North and South America. Every four years there is an international congress of nativities, usually in Europe, that any member of any national club can attend. In 2016 it will be held in northern Italy. Close to a thousand members attended the most recent congress, proof of the abiding interest in nativities today.

Be sure to check before visiting any of these displays. Hours, viewing times, exhibits, and even locations often change. Many temporary nativity exhibits also occur during the Advent season, so check for local events. Many of the museums listed here charge an admission fee.

UNITED STATES

SAN DIEGO, CALIFORNIA: The large nativity collection of Fr. Joe Carroll is on display at St. Vincent de Paul Village, 3350 East Street. There are over 600 nativities. The display is open from Advent to Epiphany, Monday through Friday from 8:00 a.m. to 4:00 p.m. and Saturday mornings. During the rest of the year, call for an appointment. Phone: 619-687-1000.

BETHLEHEM, CONNECTICUT: The Abbey of Regina Laudis is a community of contemplative Benedictine women located at 273 Flanders Road. An eighteenth-century Neapolitan nativity with 68 figures was a gift of Mrs. Loretta Hinds Howard in 1949. Mrs. Howard donated another Neopolitan nativity, the famous Angel Tree, to the Metropolitan Museum of Art in New York. The abbey is open daily, weather permitting, from 10:00 a.m. to 4:00 p.m. It is closed from January 6 to Easter Sunday. Web site: www.abbeyofreginalaudis.com.

LAFAYETTE, LOUISIANA: The Museum of the Cathedral of St. John the Evangelist is at 515 Cathedral Street in downtown Lafayette. It has an authentic Italian Baroque *presepio* with 120 figures. It is open Monday through Friday from 9:00 a.m. to 12:00 p.m. and 1:00 to 4:00 p.m. Phone: 337-232-1322. Special appointments: 337-643-6420.

FRANKENMUTH, MICHIGAN: Bronner's Christmas Wonderland at 25 Christmas Lane has nativities on display both inside and outside. The Bronner family collection is in a museum in the main building. Phone: 989-652-9931. Web site: www.bronners.com.

MINNEAPOLIS, MINNESOTA: The Westminster Presbyterian Church at 1200 Marquette Avenue displays the Martha Spencer Rogers Creche Collection of more than 200 nativities from 80 countries. The hours are Monday through Friday from 9:00 a.m. to 5:00 p.m. and Sunday from 9:00 a.m. to 12:00 p.m. Phone: 612-332-3421. E-mail: RSchwartz@wpc-mpls.org (Rodney Allen Schwartz is director of The Westminster Gallery and Archive).

SANTA FE, NEW MEXICO: The Museum of International Folk Art is on Museum Hill off Old Santa Fe Trail. The Girard Wing has many nativities collected by the famous designer Alexander Girard. The hours are Tuesday through Sunday from 10:00 a.m. to 5:00 p.m. Closed Mondays except during summer months. Phone: 505-476-1200.

AKRON, OHIO: The Nativity of the Lord Jesus Catholic Church is at the corner of Killian and Myersville roads. The church museum has more than 500 nativities from around the world. Hours are 9:00 a.m. to 4:00 p.m. weekdays, and before and after Masses on Saturdays and Sundays. Phone: 330-699-5086. Web site: www.nativity ofthelord.org.

DAYTON, OHIO: The Marian Library at the University of Dayton has a collection of over 2,000 nativities from around the world. There are seasonal displays and a small year-round creche museum. Also open by appointment is the Creche Workshop, where additional sets are on display. The hours are Monday through Friday from 8:30 a.m. to 4:30 p.m. Phone: 937-229-4214. Web site: www. udayton.edu/mary.

CHALFONT, PENNSYLVANIA: Byers' Choice Ltd. is 30 miles north of Philadelphia at 4355 County Line Road. It has an eighteenth-century Italian *presepio* and almost 200 other nativities from around the world. The hours are Monday through Saturday from 10:00 a.m. to 5:00 p.m., and 12:00 to 5:00 p.m. on Sundays. Phone: 215-822-6700. Web site: www.byerschoice.com.

GROVE CITY, PENNSYLVANIA: At Slovak Folk Crafts, 1605 S. Center Street Ext., is the only known mechanical nativity in the United States. Hand carved of basswood, it has 82 moving figures depicting Slovakian folk life. It's modeled after an even larger mechanical nativity in Slovakia. Open Monday through Saturday from 9:00 a.m. to 5:00 p.m. Phone: 866-756-8257. Web site: www.slovakfolkcrafts.com.

PARADISE, PENNSYLVANIA: The National Christmas Center is at 3427 Lincoln Highway. It has over 300 nativities, including a life-sized, hand-carved, 20-piece, eighteenth-century Italian nativity, and a Moravian putz. Hours vary, so check before going. Phone: 717-442-7950. Web site: www.nationalchristmascenter.com.

SANGER, TEXAS: "Bethlehem in Denton County" is five miles north of Denton on I-35 off exit 473. The address is 990 Milam Road East. Judy Klein's collection of 2,850 nativities may be seen evenings and weekends by appointment only. Groups are limited to 10 people. Phone: 940-458-3563. E-mail: jmk@advantexmail.net. Web site: www.bethlehemindentonco.com/bethsweb.html.

MENOMONEE FALLS, WISCONSIN: The Holy Cross Lutheran Church is at W156 N8131 Pilgrim Road. It has a collection of 250 nativities from more than 40 countries. Hours are 1:00 to 3:00 p.m. Monday through Friday, and 9:00 a.m. to 1:00 p.m. on Sundays. Phone: 262-251-2740.

OSHKOSH, WISCONSIN: The Algoma Boulevard United Methodist Church at 1174 Algoma Boulevard has a collection of more than 1,000 nativities on display during regular church hours on Sundays from 8:00 a.m. to 12:00 p.m. For daily hours, and to be sure the church is open, call 920-231-2800. Web site: www.abumc.org.

AUSTRIA

CHRISTKINDL (near Steyr): The Mechanical Manger has 300 moving figures accompanied by a Bohemian cylinder organ. Karl Klauda (1855–1939) created the scene. Open late November to January 6 from 9:00 a.m. to 5:00 p.m. Phone: +43-7252-54622. Web site: www.pfarre-christ kindl.at.

CHRISTKINDL: The Pottmesser Manger is one of the largest nativities in the world. There are almost 800 figures. Ferdinand Pottmesser began making them in 1955.

DORNBIRN: This is in the Bregenzerwald at the entrance to the Rappenlochschlucht. The Krippenmuseum here has a collection of local and international nativities. Open May 1 to January 6, Tuesday through Sunday from 10:00 a.m. to 5:00 p.m. Groups can visit year-round with a reservation. Phone: +43-0-5572-25842. E-mail: krippenmuseum. dornbirn@cable.vol.at. Web site: www.krippenmuseum-dornbirn.at.

INNSBRUCK: The Tiroler Volkskunstmuseum (Museum of Tyrolean Folk Art) at Universitätsstraße 2 has many nativities. There is an extended display of them at Christmas. The hours are from 9:00 a.m. to 5:00 p.m., except for Sundays, when it closes at 12:00 p.m. Phone: +43-0-512-584302. Web site: www.tiroler-landesmuseen.at/html.php/de/volkskunstmuseum.

SAALFELDEN (south of Salzburg): The Heimatmuseum Schloss Ritzen (Ritzen Castle Heritage Museum) may have the largest collection of nativities in the Alpine region. It is open daily from 10:00 a.m. to 12:00 p.m. and 2:00 to 5:00 p.m. from mid-June to mid-September. From mid-September to mid-June it is open Wednesdays and weekends from 2:00 to 4:00 p.m. Phone: +43-0-6582-72759.

STEYR: The Museum der Stadt Steyr (Steyr Municipal Museum) is at Grünmarkt 26. There are more than 200 figures in the Count Josef Lamberg nativity. Also on display is the Bethlehem Nativity, a gift to the city in 2001. A stick puppet show is presented during the holiday season, by reservation. In December it is open daily from 10:00 a.m. to 4:00 p.m. The rest of the year it is closed on Mondays and is not open past 3:00 p.m. Phone: +43-7252-575348. E-mail: gegenhuber@steyr.gv.at. Web site: www.steyr.at/system/web/zustaendigkeit.aspx?detailonr=3131.

VIENNA: The Österreichisches Museum für Volkskunde (Austrian Folklore Museum) at Laudongasse 15–19 has a large Neapolitan presepio, as well as some Austrian nativities. It is open Tuesday through Sunday from 10:00 a.m. to 5:00 p.m., but closed on holidays. Phone: +43-1-406-89-05. Web site: www.volkskundemuseum.at.

BELGIUM

HERGERSBERG: The ArsKrippana is in an old customs building on the border between Germany and Belgium. It is east of Malmedy, Belgium, and southeast of Monschau. The museum has over 200 nativities from around the world and other related exhibits. The hours are 10:00 a.m. to 6:00 p.m. Tuesday through Sunday. Phone: +32-0-80-54-87-29 or +49-0-6557-92-06-30. Web site: www.krippana.de.

BRAZIL

SÃO PAULO: Museu de Arte Sacra is at Avenida Tiradentes 676, Ponte Pequena. An eighteenth-century Neopolitan nativity with 1,620 pieces was newly installed in 2002. Nativities from Brazil and other countries are also on display. It is open Tuesday through Sunday from 10:00 a.m. to 6:00 p.m. Phone: +55-11-3326-1373, +55-11-3326-5393, or +55-11-3326-3336.

CANADA

MONTREAL: The Musée de l'Oratoire is at 3800 Queen Mary Road. Its collection contains more than 1,200 nativities from 100 countries. Not all are on display, but 330 are shown from November through February, and more than 200 are shown year-round. It is open daily from 10:00 a.m. to 5:00 p.m. Phone: 514-733-8211, ext. 2793. Web site: www.saint-joseph.org/en_1102_index.php.

RIVIÈRE-ÉTERNITÉ: This is a village in the Saguenay Region of Quebec, near Chicoutimi. There are many life-sized, hand-carved nativities, all of which were carved by local artists. The local church has a large collection of international nativities. Appointments are necessary to enter the church in the off-season. French is the preferred language here, and English is scarce.

SAINT-JEAN-PORT-JOLI (103 kilometers northeast of Quebec City): There is a collection of locally made nativities in an eighteenth-century church. One large nativity was made by 21 local wood-carvers. It is open from June to October, and again from December to January. Phone: 418-598-3023.

CZECH REPUBLIC

JINDŘICHŮV HRADEC (65 kilometers northeast of České Budějovice): The Muzeum Jindřichohradecko on Balbínovo Náměstí (Balbin Square) has a mechanized nativity with almost 1,400 figures; over 100 figures move. It was made by Tomáš Krýza (1838–1918). It is open daily from June to September from 8:30 a.m. to 12:00 p.m. and from 12:30 to 5:00 p.m. It is closed on Mondays from January through June. Phone: +420-384-363-660. Web site: www.mjh.cz.

KARLŠTEJN (30 kilometers west of Prague): The Muzeum Betlémů Karlštejn (Karlštejn Museum of Nativities) is in a fourteenth-century building below the castle. It has the largest puppet nativity in the Czech Republic, the Karlštejn Royal Nativity Scene, with movable figures of famous people in Czech history. It is open daily from 10:00 a.m. to 5:00 p.m., except for January through March, when it is open only on weekends.

TŘEBECHOVICE POD OREBEM: The Třebechovické Muzeum Betlémů (Třebechovické Museum of Nativities) offers a large permanent exhibit of historic and mechanical nativities, including a late nineteenth-century mechanized nativity of more than 2,000 figures. Many of these figures are mechanized. The hours are 9:00 a.m. to 4:00 p.m. from January through April. From May through December it is open till 5:00 p.m., except for Mondays and the month of November.

TŘEBÍČ (60 kilometers west of Brno): The Muzeum Vysočiny Třebíč (Highlands Museum of Třebíč) traces the origins of nativity making in Třebíč from the late eighteenth century. There is also a mechanized nativity. This museum is currently closed for renovation. When it reopens, it is open Tuesday through Sunday from 8:00 a.m. to 5:00 p.m. Phone: +420-568-824-658. Web site: www.zamek-trebic.cz.

Note: The Czech Republic has many more nativities. For a more complete listing, see the Web site of Friends of the Creche (www.friendsofthecreche.org).

ECUADOR

CUENCA: Museo de las Conceptas is located at Hermano Miguel 6-33 at Juan Jaramillo. A collection of Ecuadorian nativities demonstrates the style and culture of Cuenca and the Andes. A large nativity is set up at Christmas. On Christmas Eve, a live nativity pageant occurs on the plaza for eight hours. The museum is open Monday through Friday from 9:00 a.m. to 1:00 p.m. and 3:00 to 6:00 p.m. On Saturdays it is open only from 9:00 a.m. to 1:00 p.m. Phone: +593-7-830625.

FRANCE

ARLES: The Museon Arlaten at 29 rue de la Republique has a large collection of nativities from the eighteenth to the twentieth century. Its hours are 10:00 a.m. to 12:00 p.m. and 2:30 to 6:00 p.m. during April through September. The rest of the year it closes at 5:00 p.m. and on Mondays. Phone: +33-04-90-93-80-55. This museum is currently closed for renovation and will reopen in 2014.

FONTAINE-DE-VAUCLUSE: The Musée du Santon et Traditions de Provence is at Place de la Colonne. It contains 2,000 *santons*, 60 of them movable. The work of 95 *santonniers* of Provence is represented. Hours are 10:00 a.m. to 6:00 p.m. daily. Phone: +33-04-90-20-20-83. Web site: www.musee-du-santon.org.

LOURDES: The Musée de la Nativité—La Crèche Animée is at 21 Quai Saint-Jean. It has many dioramas and animated scenes. Its hours are 9:00 a.m. to 12:00 p.m. and 1:30 to 7:00 p.m. Phone: +33-05-62-94-71-00.

PIERREFEU-DU-VAR: The Musée du Santon at Château de l'Aumérade, Route de Puget-Ville, has a private collection of more than 1,800 *santons* from the eighteenth century to the present, arranged as a nativity. Hours are from 8:00 a.m. to 12:00 p.m. and 2:00 to 5:30 p.m. Monday through Saturday. The hours vary depending on the season. Phone: +33-04-94-28-20-31.

GERMANY

DIEßEN AM AMMERSEE: The Traidkasten building is next to the Marienmünster. A collection of nativities from around the world is open to visitors between Christmas and Epiphany in the Traidkasten building. The famous eighteenth-century nativity known as the *Schmädl-Krippe* is in the Marienmünster, the splendid Baroque church that serves as the Klosterkirche. A copy of this nativity in pewter is on pages 28–29. The church stands on the highest point of the town, up the street from the pewter company that made the reproduction, and its tall tower will help locate it. The church office fax is +49-8807-9489420.

DRESDEN: The Museum für Sächsische Volkskunst (Saxony Folk Art Museum) is at Köpckestraße 1 in the Jägerhof on the east side of the Elbe River. It has German nativities, including a mechanical one dating from 1589. Open Tuesday through Sunday from 10:00 a.m. to 6:00 p.m. Phone: +49-03-51-49-14-45-02.

FREISING (north of Munich near the end of the S1 S-Bahn line): The Domberg Museum has a small but choice collection of European nativities and an eighteenth-century Neapolitan *presepio*. Hours are 10:00 a.m. to 5:00 p.m. Tuesday through Sunday. It is closed Mondays and special holidays. Phone: +49-08161-487-90. Web site: www.dioezesanmuseum-freising.de.

MUNICH: The Bayerisches Nationalmuseum (Bavarian National Museum) is at Prinzregentenstraße 3. This museum has one of the finest collections of European nativities dating from the late seventeenth century to the early nineteenth century. Max Schmederer (1854–1917) collected nativities from Bavaria, Tyrol, Moravia, northern Italy, Sicily, and Naples, and he gave them to the museum with the condition that they be displayed exactly as he told them. This very popular exhibit, on the lower level of the museum, is not always open. The hours are 10:00 a.m. to 5:00 p.m. Tuesday through Sunday. The museum is open till 8:00 p.m. on Thursdays. It is closed Mondays and holidays. Phone: +49-89-21124-01.

MUNICH: Schloss Schleißheim (Schleißheim Palace) is on the outskirts of Munich, in Oberschleißheim. One of the buildings, the Old Schleißheim Palace, contains some of the nativities collected by Gertrud Weinhold. The rest of her collection is in Berlin.

ITALY

BRESSANONE: The Museo Diocesano includes nativities made by two famous nativity makers, Franz Xavier Nissl and Joseph Benedikt Probst. This museum is open from April through October, Tuesday through Sunday. From the end of November to Epiphany, it is open daily from 10:00 a.m. to 5:00 p.m. It is closed Christmas Eve and Christmas Day.

CALTAGIRONE (Sicily): Museo Internazionale dei Presepi is at Largo S. Luigi 2. The collection of nativities is both local and international. It is open from November to May, 9:30 a.m. to 1:30 p.m., and 3:00 to 9:00 p.m.

CASERTA: At La Reggia, the Royal Palace, is the Neapolitan *presepio* of Spanish Prince Charles of Bourbon, King of Naples, built in 1734. There are 1,200 figures. Hours are 9:00 a.m. to 6:00 p.m. Monday through Sunday. It is closed on Tuesdays.

DALMINE (near Bergamo): The Museo del Presepio is at Via XXV Aprile, 179. The large nativity collection is from Italy and around the world. During December and January the hours are from 2:00 to 5:00 p.m. on weekdays, and on Sundays from 9:00 a.m. to 12:00 p.m. and 2:00 to 7:00 p.m. The rest of the year it is open Sundays and holidays from 2:00 to 6:00 p.m. Web site: www.museodelpresepio.com.

GRECCIO: The Church of the Nativity is built on the spot where Saint Francis of Assisi created an outdoor nativity with live animals in 1223. See where it all began. There is a large *presepio* and nativity wall plaques inside, and a small display of nativities on the second floor.

GIARRE (Catania, Sicily): The Museo del Presepe is at Via Meli 3, and includes fine nativity dioramas made by local people as well as international nativities. From

December 8 to January 6 it is open daily from 4:00 to 7:30 p.m. From January 7 to December 7 it is open on Saturdays, Sundays, and holidays from 5:00 to 7:00 p.m. It is closed in July and August, but open year-round for groups and school children. Phone +39-095-934265.

LUTAGO/AHRNTAL (South Tyrol): The Museo Maranatha is at Via Weißenbach 17. Some nativities are displayed year-round. It is open Monday through Saturday from 9:00 a.m. to 12:00 p.m., and from 2:00 to 6:00 p.m. On Sundays the hours are 2:00 to 5:00 p.m. Web site: www.krippenmuseum.com.

NAPLES: At the Chiesa de San Domenico Maggiore, there are life-sized polychrome wooden nativity figures from the fifteenth century.

NAPLES: The Chiesa di Santa Chiara, near Via San Gregorio Armeno, has a seventeenth-century theatrical nativity with many figures. The cloisters are open daily from 8:00 a.m. to 1:00 p.m. and 4:00 to 7:00 p.m.

NAPLES: The Chiesa di Santa Maria in Portico has an important nativity with 24 large figures by Giuseppe Picano and Giacomo Colombo. A few figures still exist from the original 1647 nativity ordered by Duchess Orsini de Gravina.

NAPLES: The Museo di Capodimonte is at Via Miano 2. One large Italian *presepio* is in a five-by-five-foot cabinet. The museum is open daily, except Wednesdays, from 8:30 a.m. to 7:30 p.m.

NAPLES: The Museo Nazionale di San Martino (San Martino National Museum) is on the grounds of the Certosa di San Martino, Via Tito Angelini 22, in the Vomero district. Famous *presepios*, including one by Michele Cuciniello, are in rooms 32 through 38. The hours are 8:30 a.m. to 7:00 p.m., Tuesday through Sunday. Phone: +39-081-578-1769.

NAPLES: Via San Gregorio Armeno is a street lined with workshops making nativities and shops selling them.

PALERMO (Sicily): In the Museo Etnografico Giuseppe Pitrè there is a large seventeenth-century nativity by Giovanni Matera, as well as eighteenth-century nativities.

ROME: The Basilica del Santi Cosma e Damiano is at Via dei Fori Imperiali 1. There is a very large nativity here dating from 1750. Phone +39-06-692-0441.

ROME: The Museo Tipologico Internazionale del Presepe, founded by Angelo Stefanucci, is at Via Tor dè Conti 31A. The museum has 2,000 nativities from around the world. From Christmas to Epiphany it is open daily from 4:00 to 8:00 p.m. From September to June it is open Wednesdays and Saturdays from 5:00 to 8:00 p.m. Phone: +39-0-66796146. Web site: www.presepio.it/museo-del-presepio-roma.php#.UHRBtY58u-I.

TRAPANI (Sicily): The Museo Regionale Conte Agostino Pepoli is at Via Conte Agostino Pepoli 152, next to the Santuario della Madonna di Trapani. There are three rooms of nativities on the first floor. It is open Tuesday through Saturday from 9:00 a.m. to 1:30 p.m. On Sundays and holidays it closes at 12:30 p.m.

POLAND

KRAKOW: Muzeum Etnograficzne is in the Old Town Hall, Plac Wolnica, in the Kazimierz District. It has a collection of village nativity scenes. It is open on Tuesdays, Wednesdays, Fridays, and Saturdays from 11:00 a.m. to 7:00 p.m. On Thursdays it is open till 9:00 p.m. On Sundays it closes at 3:00 p.m.

KRAKOW: Muzeum Historyczne Miasta Krakowa (Historical Museum of the City of Krakow) is in the main square at Rynek Główny 35. It includes the largest collection in the world of Krakow-style nativities, the *szopkę krakowska*, but they may not be on permanent display. The museum sponsors a competition every year for new *szopkę* on the first Thursday of December. The entries are brought to the main square, where they are displayed and judged before being taken to the museum. It is closed Mondays and Tuesdays, but is open daily during the holiday season. Phone: +48-12-426-50-60. Web sites: www.mhk.pl and www.krakow-info.com/szopki.htm.

WAMBIERZYCE: This small village is about 100 kilometers from Wroclaw. It has been a pilgrimage site since the Middle Ages. The Ruchoma Szopka, a mechanical nativity of 800 pieces, was built at the end of the nineteenth century by Longinus Wittig, a local blacksmith and clockmaker. From May to September it is open Tuesday through Sunday from 9:00 a.m. to 6:00 p.m. From October to April it is open from 10:00 a.m. to 3:45 p.m.

PORTUGAL

ESTREMOZ: The Municipal Museum in the Upper Town has local eighteenth- and nineteenth-century nativities. It is open Tuesday through Saturday from 10:00 a.m. to 12:30 p.m., and from 2:00 to 5:00 p.m. From April through September it is open from 3:00 to 7:00 p.m.

LISBON: The Basilica da Estrela is at Praça da Estrela on Estrela Square. An eighteenth-century creche here originally had over 500 pieces. It is attributed to Joaquim Machado de Castro. This is open daily from 8:00 a.m. to 1:00 p.m., and from 3:00 to 8:00 p.m.

LISBON: The Museu Nacional de Arte Antiga (National Museum of Ancient Art) is on Rua das Janelas Verdes 9. There are many famous historical nativities on display here. Hours are Tuesday 2:00 to 6:00 p.m., and Wednesday through Sunday 10:00 a.m. to 6:00 p.m. It is closed on Mondays. Phone: +351-21-391-28-00. Web site: www.mnarteantiga-ipmuseus.pt.

SLOVAKIA

RAJECKÁ LESNÁ (in northern Slovakia, 30 kilometers south of Zilina): The Slovenského Betlehema (Slovak Bethlehem) on display here is 27 feet long and was carved by Jozef Pekara. There are 170 moving figures in Slovak costumes. Hours are 9:00 a.m. to 12:00 p.m. and 1:00 to 5:00 p.m. Monday through Friday. On Saturday and Sunday it is open from 10:00 a.m. to 5:00 p.m. Phone: +421-041-548-81-34.

SPAIN

ALICANTE: The Museo de Belenes at Calle de San Augustin 3 is small, but has nativities from around the world. Closed Mondays. Phone: +34-96-520-22-32.

MURCIA: The Museo Salzillo is at Plaza de San Augustin, 3. This museum is dedicated to the work of Spain's most famous Baroque sculptor, Francisco Salzillo (1707–1783). His full-sized sculptures are carried on the shoulders of the faithful in Easter processions. His famous nativity was made on a much smaller scale. There are 556 figures, including humans and animals. It was made between 1776 and 1800, so others worked to finish it after Salzillo's death. This is an important nativity. The museum is closed on Mondays. Phone: +34-968-29-18-93.

SANTA CRISTINA D'ARO (near Girona): The Monestir Cistercenc de Santa Maria de Solius (Cistercian Monastery of Santa Maria of Solius) has an exhibit of nativities made by one monk over the span of 30 years. Hours are 11:00 a.m. to 12:30 p.m. and 3:00 to 5:30 p.m. Phone: +34-972-83-70-84.

SWITZERLAND

BASEL: The Spielzeug Welten Museum is at Steinenvorstadt 1. It includes a Neopolitan *presepio* with several hundred figures. It is open daily from 10:00 a.m. to 6:00 p.m. Web site: www.spielzeug-welten-museum-basel.ch/de/.

EINSIEDELN (40 kilometers southeast of Zurich): The Diorama Bethlehem, located at Benzigerstrasse 23, is said to be the largest nativity in the world. Ferdinand Pottmesser of South Tyrol carved over 450 figures in the 1930s. It is open from May through October from 12:00 to 5:00 p.m. During Advent, till January 6, it is open from 12:00 to 4:00 p.m. Groups may see it by appointment. E-mail: info@dirama.ch. Web site: www.diorama.ch/english.